# CONTENTS

|  | Introduction | 5 |
| SECTION 1 | Dear Green Place | 8 |
| SECTION 2 | The River Clyde | 26 |
| SECTION 3 | Landmark Buildings | 36 |
| SECTION 4 | Up Sauchie, Doon Buckie, Alang Argyle | 60 |
| SECTION 5 | Around the City | 75 |

# INTRODUCTION

The current city of Glasgow began life as a small rural settlement, with St Mungo establishing a church on the site of the current Glasgow Cathedral in the sixth century. St Mungo became the patron saint of Glasgow and his influences can continue to be found throughout the city today, with several churches and schools bearing his name or that of St Kentigern – his birth name. St Mungo's presence can be found in the city's coat of arms, with the four miracles of St Mungo being represented through the bird that never flew, the tree that never grew, the bell that never rang, and the fish that never swam. St Mungo also influenced the motto of the city as 'Let Glasgow Flourish'.

The first stone of Glasgow Cathedral was dedicated in the presence of David I in 1136 and from then through the founding of the University of Glasgow in 1451, the establishment of Glasgow as a burgh, and the elevation of Glasgow to an archbishopric in 1492, Glasgow did indeed flourish, with early trade in agriculture, brewing, and fishing.

Glasgow gained the status of royal burgh from James VI in 1611 and became a hub of international trade on the River Clyde, particularly in tobacco, sugar, and cotton, along with iron ore and coal from the mines of Lanarkshire. By the early nineteenth century Glasgow had become one of the most populous cities in Europe and was producing more than half of Britain's shipping tonnage.

Glasgow gained worldwide notoriety and the city was showcased in a series of international exhibitions from 1888, culminating in the Empire Exhibition of 1938 in Bellahouston Park. These exhibitions, particularly in 1938, were attended by millions of visitors from throughout the world who were encouraged to come to Glasgow to see the incredible accomplishments of the city in architecture, engineering, and industry, as well as the famous Glasgow subway, which opened in 1896 and is now the third oldest in the world.

Despite Glasgow being a key industrial city during both world wars, particularly through shipbuilding and munitions, the city suffered through the Great Depression and the economic decline that followed. The key industries that had brought prosperity to Glasgow rapidly diminished and the city experienced high unemployment, poverty, and deprivation for many years.

From the mid-1950s, however, Glasgow saw a resurgence in fortunes through dedicated efforts to improve and regenerate the city. Substandard housing was demolished to make way for modern housing developments, a new road network was created through the city, Scottish New Towns were developed – including Cumbernauld and East Kilbride – to alleviate overcrowding, and new technologies were encouraged to bring their businesses to Glasgow.

In the 1980s Glasgow's continuing attempts to rebrand the city resulted in the award-winning Glasgow's Miles Better campaign, which ran nationwide from June 1983. In 1988 Glasgow was host to the Garden Festival, taking place on a 120-acre site on the south bank of the River Clyde. The festival brought over 4 million visitors to the city and saw the return of vintage Glasgow trams, along with the construction of an observation tower, miniature railway, and a new footbridge that linked the area with the Scottish Exhibition and Conference Centre, now

the Scottish Events Campus. The location of the 1988 Glasgow Garden Festival is now home to the Pacific Quay developments of the Glasgow Science Centre and the BBC Scotland and Scottish television studios. The festival was also used to promote Glasgow's impending hosting of the 1990 European City of Culture.

Glasgow has been in a constant period of regeneration and development ever since, with the 2014 Commonwealth Games being held in the city. The games brought large-scale development to Glasgow's east end with an improved road network, new leisure facilities (including the Emirates Arena and Sir Chris Hoy Velodrome), along with new housing and community facilities.

This book will show how some areas of the city once looked, with postcard images of Glasgow from 1900 onwards. The collection offers a fascinating insight into life in Glasgow and how the city has further matured and developed over the last century.

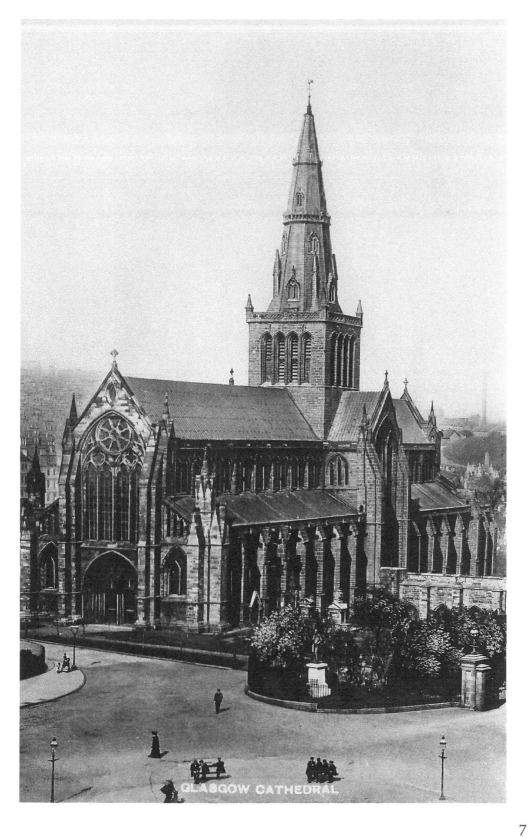

GLASGOW CATHEDRAL

# SECTION 1
# DEAR GREEN PLACE

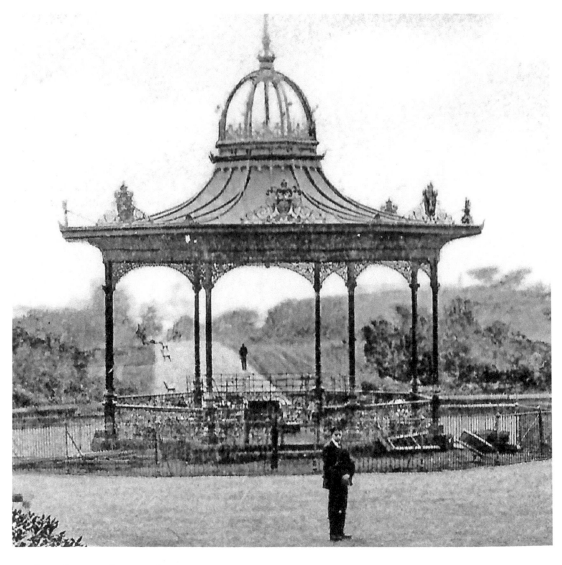

Bandstand, Springburn Park.

## Queen's Park

The 60-hectare Queen's Park is located south of the River Clyde and close to the New Victoria Hospital and Hampden Park, the national football stadium and home ground of Queen's Park Football Club. The top postcard here looks towards Victoria Road, with the spire of the former Queen's Park Parish Church seen to the right. The postcard below shows the Queen's Park ponds, which can be found alongside Pollokshaws Road. The park was acquired in 1847 and was named in memory of Mary, Queen of Scots.

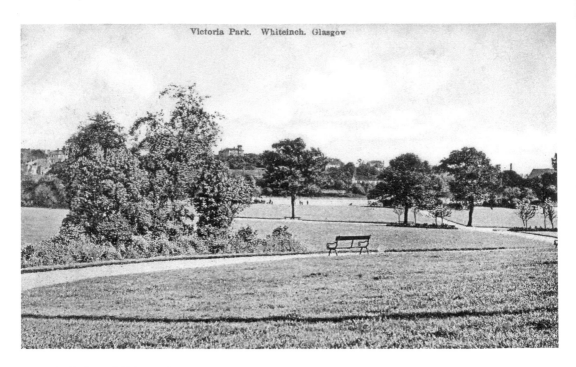

## Victoria Park and Elder Park

Victoria Park was formally opened on 2 July 1887 by Sir Andrew McLean, Lord Provost of Glasgow, and was named in honour of Queen Victoria's Golden Jubilee. A large area of the park was taken over in the early 1960s by the new approach road to the Clyde Tunnel, which has taken pedestrian, bicycle, and road traffic under the River Clyde since 3 July 1963. The tunnel connects the Whiteinch area of Glasgow with Govan, where Elder Park can be found. Elder Park was established in 1885 by Isabella Elder as a memorial to her late husband, shipbuilding magnate John Elder.

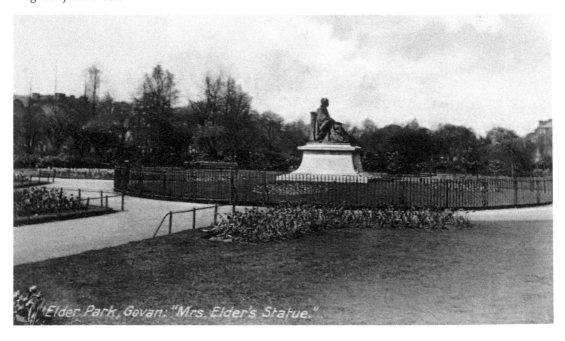

"Elder Park, Govan: "Mrs. Elder's Statue."

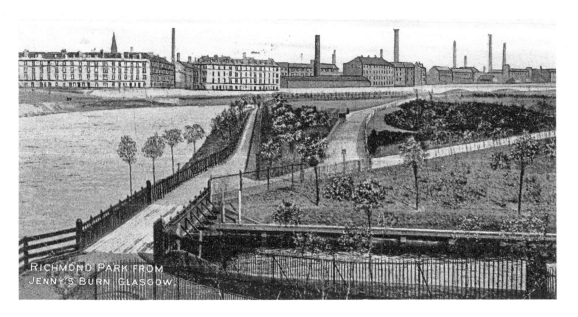

Richmond Park and the Doulton Fountain

Named after Sir David Richmond, Lord Provost of Glasgow, Richmond Park opened in September 1899 and is located in the Gorbals, close to the Southern Necropolis. In 2003 Glasgow City Council agreed an Oatlands masterplan, which resulted in a large area of Richmond Park being released for housing. Just across the River Clyde from Richmond Park is Glasgow Green, home to the Doulton Fountain. The fountain was built by Royal Doulton to commemorate the reign of Queen Victoria and was presented to Glasgow for the 1888 International Exhibition. After falling into disrepair, the fountain was restored in 2002 and moved to its current location in front of the People's Palace.

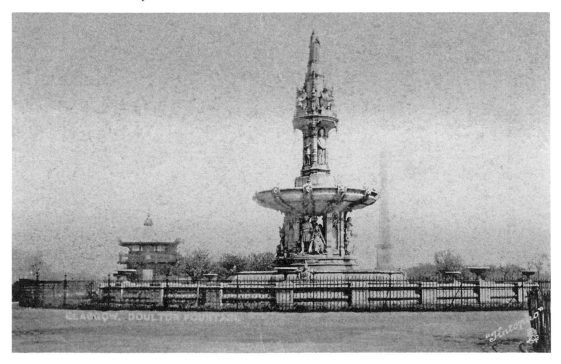

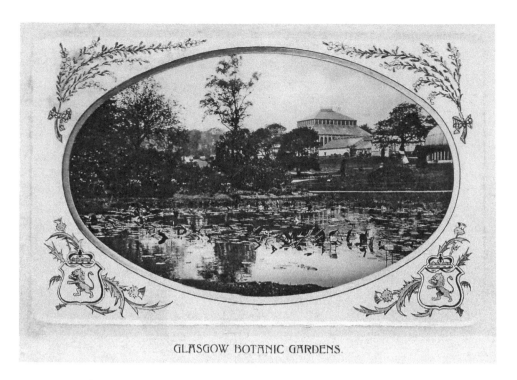

GLASGOW BOTANIC GARDENS.

## Botanic Gardens

Thomas Hopkirk, a local botanist, founded Glasgow's Botanic Gardens in 1817 with the donation of 3,000 plants to a new botanical collection in an 8-acre location in the Sandyford area – at the western edge of Sauchiehall Street. The gardens were created with the support of the University of Glasgow and, under the curation of William Jackson Hooker, Professor of Botany, by 1825 the collection numbered 12,000. In 1839 Glasgow's Botanic Gardens relocated to a 50-acre site at Great Western Road, where it remains today.

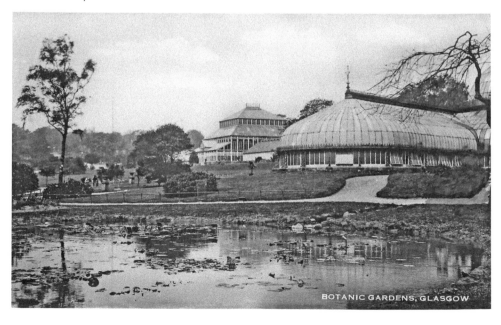

BOTANIC GARDENS, GLASGOW

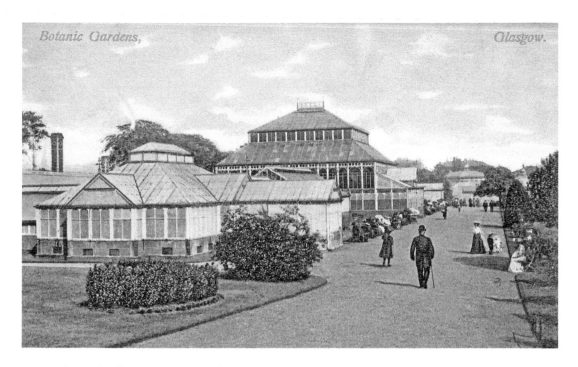

Winter Gardens, Botanic Gardens

The glasshouses in the Botanic Gardens were opened to the public in their current location in 1842. Originally, only members of the Royal Botanic Institution were entitled to free entry to the gardens, with public access only available at weekends and at the cost of 1d. Financial difficulties resulted in the gardens being taken over by Glasgow Corporation (now Glasgow City Council) in 1887, although the gardens remained outside the city boundary until 1891 when the City of Glasgow Act expanded the city further.

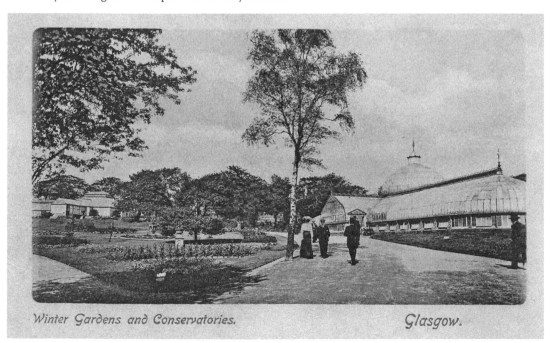

Winter Gardens and Conservatories.     Glasgow.

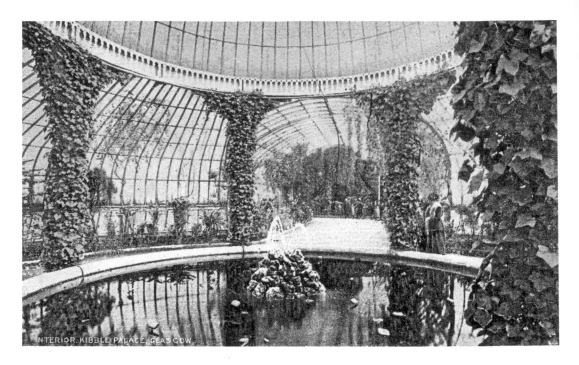

INTERIOR. KIBBLE PALACE, GLASGOW.

## Kibble Palace and River Kelvin

Originally the private conservatory of John Kibble at Coulport on Loch Long, Kibble Palace was dismantled and transported to Glasgow by barge in 1871 where it was reconstructed and expanded within the Botanic Gardens. Kibble Palace was originally used as a concert hall and meeting place when it opened in 1873 but now, having reopened in 2006 following extensive refurbishment, houses a large selection of the botanical collection along with fine marble statues, including King Robert of Sicily by renowned sculptor George Henry Paulin. The neighbouring River Kelvin stretches for 22 miles from east of Kilsyth, through Kirkintilloch and Maryhill, passing the Botanic Gardens, ultimately flowing into the River Clyde.

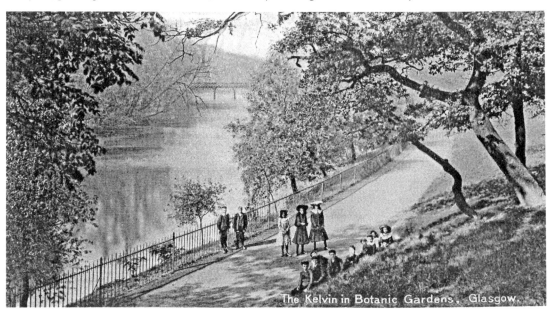

The Kelvin in Botanic Gardens, Glasgow.

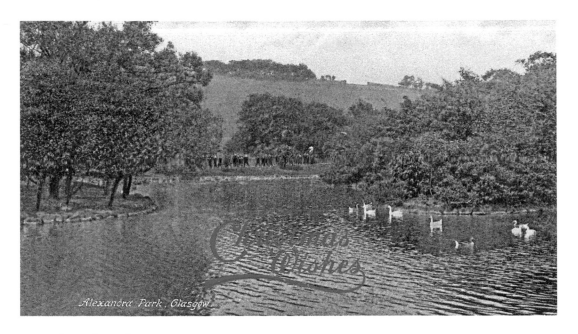

Alexandra Park

Taking its name from Princess Alexandra, who officially opened the park in 1870, Alexandra Park is located to the east of the city and initially extended from the Monkland Canal to Cumbernauld Road. The land was acquired from the Stewart family, who held ownership of the area for several generations, and was expanded following a gift of 5 additional acres from Alexander Dennistoun, after whom the surrounding residential area is now named. A key feature of Alexandra Park is the A-listed Saracen Fountain, which was gifted to Glasgow following the 1901 International Exhibition and has been located in the park since 1914.

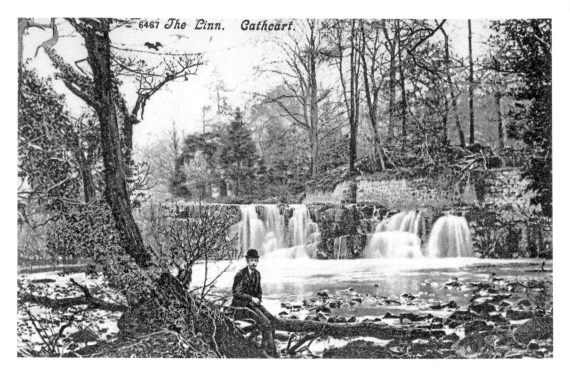

6467 The Linn. Cathcart.

## The Linn

Linn Park, Glasgow's second largest after Pollok Country Park, is located in the south of the city and was formerly a country estate before being acquired by Glasgow Corporation in 1919. The park is named after the nearby waterfalls on the White Cart Water, a tributary of the River Clyde, with 'linn' being an old Scots word for waterfall. White Cart Water flows from the edge of Eaglesham Moor in East Renfrewshire to meet with the Black Cart Water close to Glasgow Airport.

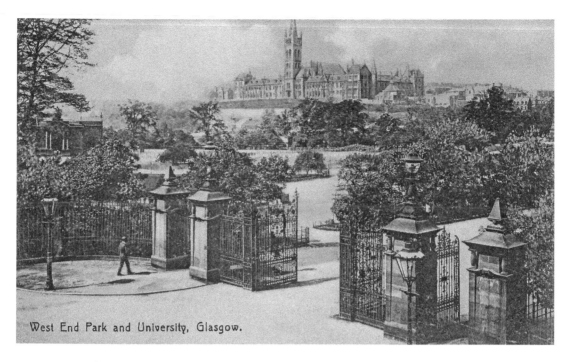

West End Park and University, Glasgow.

### West End Park and Stewart Memorial Fountain

Now known as Kelvingrove Park, West End Park was formed in 1852 following the purchase of the Kelvingrove and Woodlands estates for the sum of £99,569. The park was the first purpose-designed and constructed park in Scotland and was designed by Sir Joseph Paxton, who also designed the Crystal Palace in London. The Stewart Memorial Fountain was installed in 1872 to commemorate Lord Provost Robert Stewart, who oversaw the delivery of Glasgow's water supply from Loch Katrine.

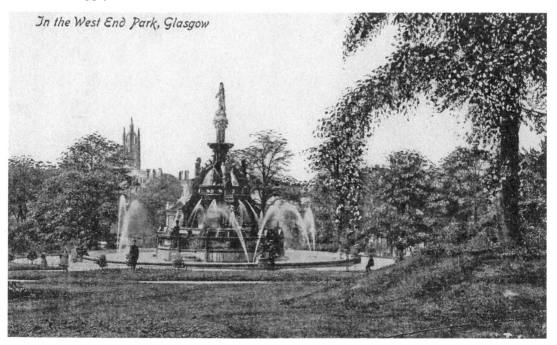

In the West End Park, Glasgow

West End Park

Hearty Greetings from Glasgow.

## West End Park and Bandstand

Like most Victorian parks, West End Park included a pond and a bandstand, here situated towards the eastern edge of the park. This original bandstand was in the traditional cast-iron, circular style and looked towards the fine elevated houses of Park Terrace. The bandstand has since been replaced by an amphitheatre, which, following a £2.1 million refurbishment in 2014, continues to offer an annual programme of live music and performances from local and internationally renowned acts.

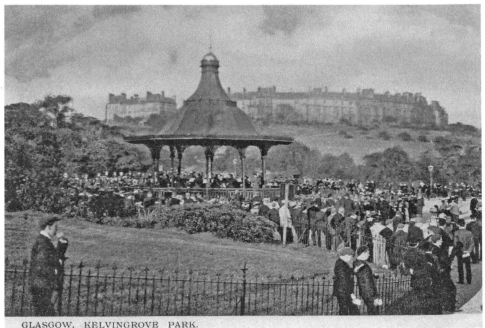

GLASGOW. KELVINGROVE PARK.

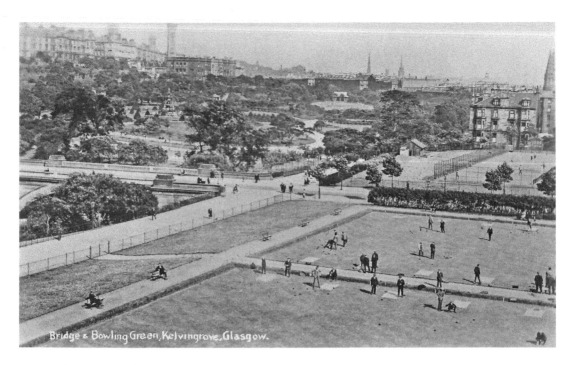

Bridge & Bowling Green, Kelvingrove, Glasgow.

## Kelvingrove Park

The 34-hectare Kelvingrove Park has hosted a range of recreational activities for many years, such as these bowling greens and tennis courts, and continues to do so today. These postcards, featuring images captured from the Kelvingrove Art Gallery and Museum, look east towards Park Gardens, Charing Cross, and Sauchiehall Street. The tower seen on the left of both postcards marks the University of Glasgow's former Trinity College of theological studies in Lynedoch Place.

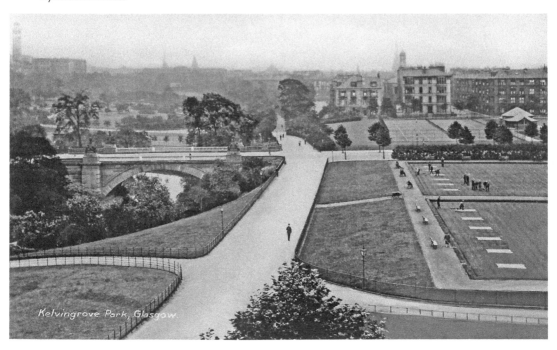

Kelvingrove Park, Glasgow.

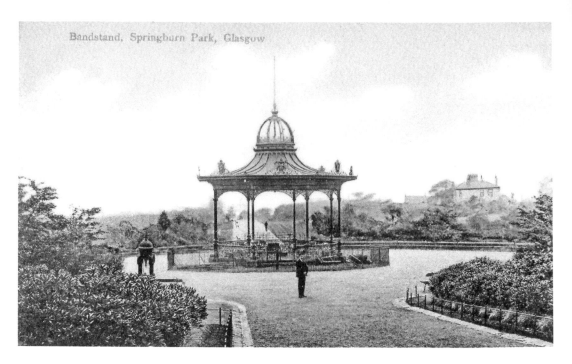

Bandstand, Springburn Park, Glasgow

## Springburn Park

To the north-east of the city lies the area of Springburn, with Springburn Park acquired by Glasgow Corporation in 1892 from mostly agricultural land. Springburn Park today is 31 hectares in size and includes the crown of Balgrayhill, reaching 364 feet above sea level and providing excellent views over much of west Scotland. Springburn Winter Gardens, located close to the bandstand, was created as a condition of a £12,000 payment secured for the construction of Springburn Public Halls. The A-listed Springburn Winter Gardens has lain derelict for a number of years but there is an ongoing campaign to restore the structure and return it to active use.

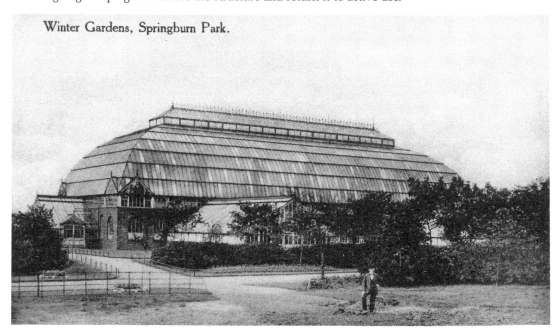

Winter Gardens, Springburn Park.

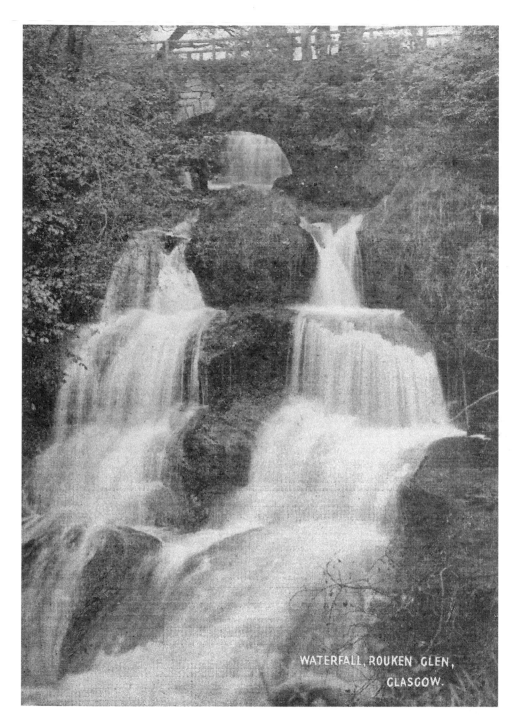

WATERFALL, ROUKEN GLEN, GLASGOW.

## Rouken Glen

Located to the south-west of the city, in the Giffnock area of East Renfrewshire, Rouken Glen Park was officially opened on 25 May 1906 and is named for the former Rook End Meal Mill, with its origins dating back to the early sixteenth century. The park includes a system of weirs and waterfalls that were constructed to control the water flow in order to power the linen and cotton factories in the Thornliebank area.

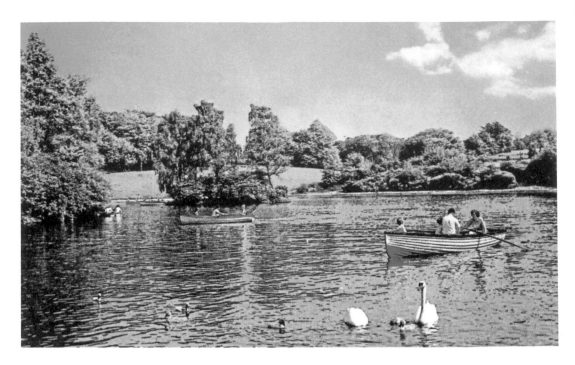

## Rouken Glen Park and Pollok Estate

The Rouken Glen Park boating pond, seen on the above postcard, is also known locally as Swan Lake and was originally used as the estate curling pond before being expanded in the 1920s. The boating pond has been significantly improved through restoration works in recent years. Just five minutes away from Rouken Glen Park lies Pollok Country Park and Estate, seen below. Pollok Estate was home to the Maxwell family for over 700 years before it was gifted to Glasgow Corporation in 1966. Pollok Country Park was named the Best Park in Britain in 2006 and the Best Park in Europe in 2008.

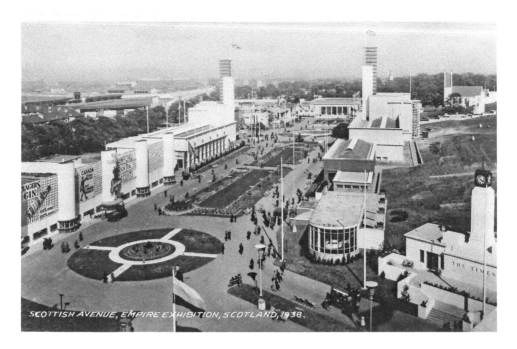

SCOTTISH AVENUE, EMPIRE EXHIBITION, SCOTLAND, 1938.

Empire Exhibition, 1938

The Empire Exhibition was held at Bellahouston Park, located to the west of the city, from May to December 1938 and attracted around 12 million visitors to Glasgow from around the world. The exhibition was held to celebrate the achievements of the former British Empire and to generate investment following the economic depression. The exhibition featured pavilions centred on key areas of excellence including industry and engineering, with the largest countries of the Empire having their own national pavilions.

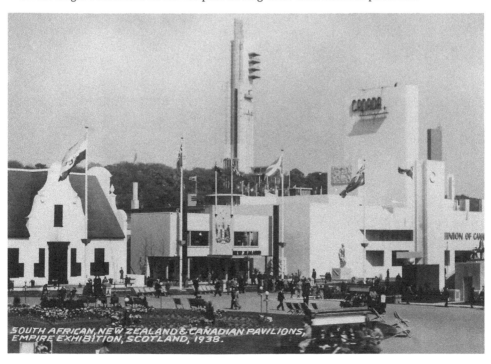

SOUTH AFRICAN, NEW ZEALAND & CANADIAN PAVILIONS, EMPIRE EXHIBITION, SCOTLAND, 1938.

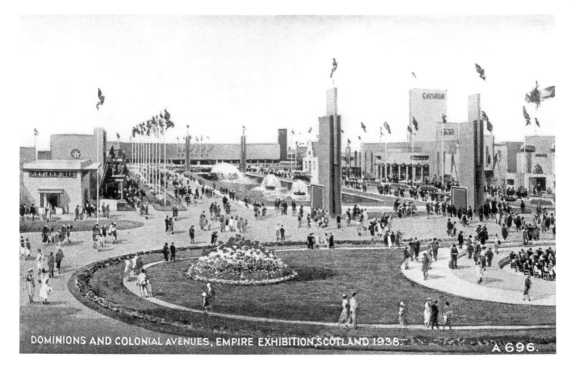

DOMINIONS AND COLONIAL AVENUES, EMPIRE EXHIBITION, SCOTLAND 1938. A 696.

## Empire Exhibition, 1938

The exhibition was designed by a team of architects including Basil Spence, whose other buildings include Coventry Cathedral and the original façade of Glasgow Airport, and Jack Coia, who also designed St Peter's Seminary and Notre Dame College. A football tournament called the Empire Exhibition Trophy was held in conjunction with the exhibition, with four teams from Scotland and four teams from England taking part. The tournament was won by Celtic, who beat Everton in the final after extra time.

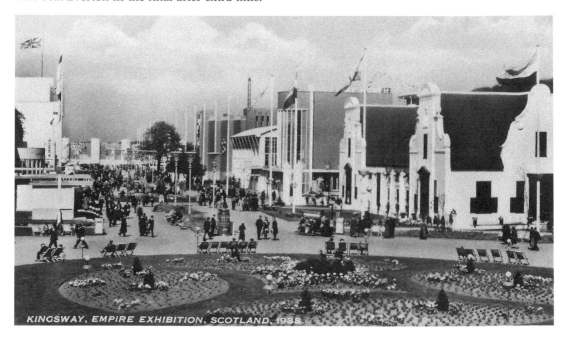

KINGSWAY, EMPIRE EXHIBITION, SCOTLAND, 1938.

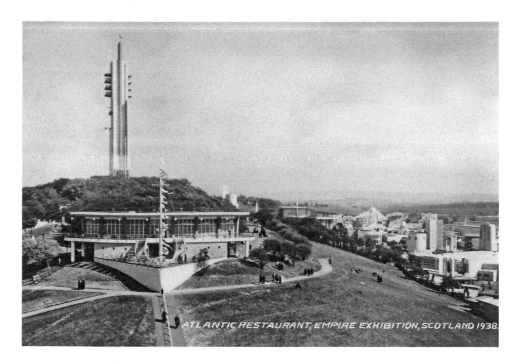

ATLANTIC RESTAURANT, EMPIRE EXHIBITION, SCOTLAND 1938.

## Empire Exhibition, 1938

The summer of 1938 was one of the wettest summers on record, which is reflected in the reverse of this postcard, stating: 'the weather has been most truly awful most of the time.' The Tait Tower, named after Thomas Tait who led the design team, was originally designed to remain a permanent feature of Bellahouston Park but was demolished in 1939. The Palace of Art is the only remaining building in the park today but the South Africa Pavilion was demolished and rebuilt by ICI at Ardeer in North Ayrshire, and the Palace of Engineering was demolished and rebuilt at Prestwick Airport and is now owned by Spirit AeroSystems.

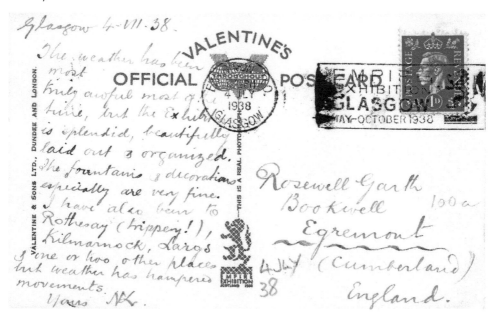

# SECTION 2
# THE RIVER CLYDE

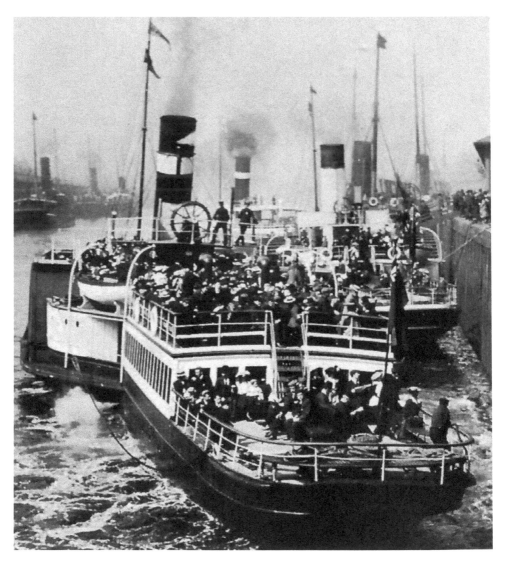

Broomielaw, River Clyde.

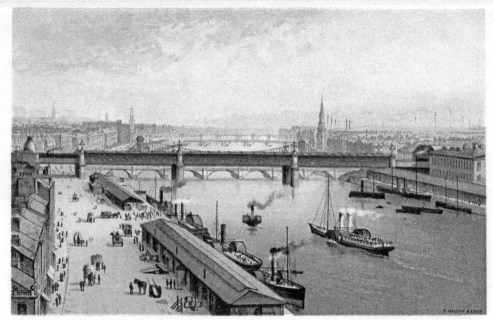

THE BROOMIELAW, GLASGOW—LOOKING EAST

## River Clyde

The River Clyde is one of the longest rivers in Scotland, flowing from south Lanarkshire and through the World Heritage Site at New Lanark, feeding Strathclyde Loch at Motherwell, and into Glasgow from the east. The shallow river was originally problematic for large ships, which had to dock at Port Glasgow or Greenock to transport their goods into the city by alternative methods. The river was deepened and larger ships could come directly into the city by the late nineteenth century.

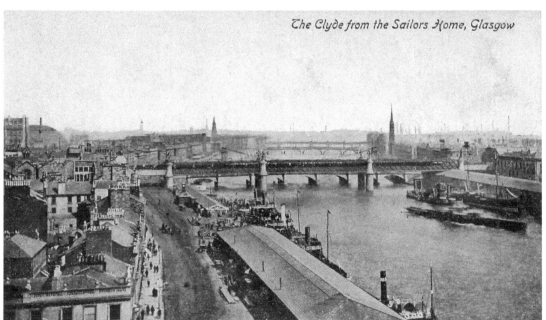

The Clyde from the Sailors Home, Glasgow

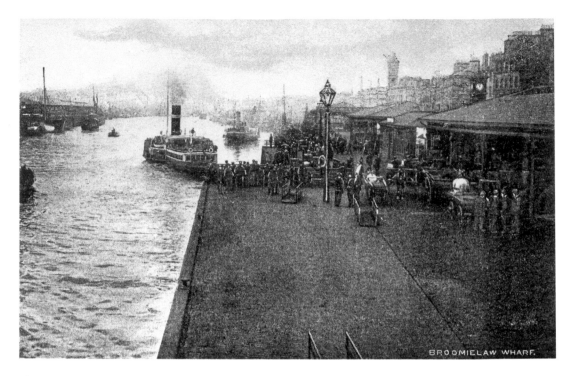

The Broomielaw

Located along the north bank of the River Clyde, the Broomielaw was the site of Glasgow's first quay from the late seventeenth century. While best known for shipping and industry, generations of Scottish people used the river for transport to their favourite holiday locations including Dunoon, Rothesday, and Arran, particularly at the Glasgow Fair. The Broomielaw continues to be used as a quay today for small boats, although the surrounding area is now the home to Glasgow's International Financial Services District.

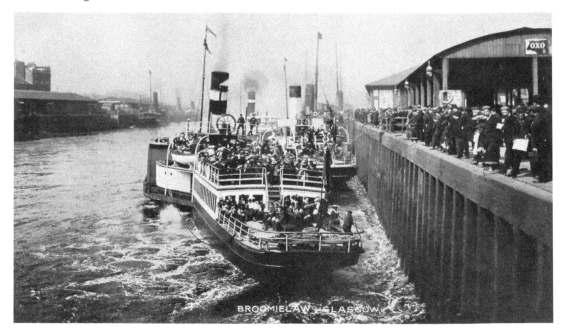

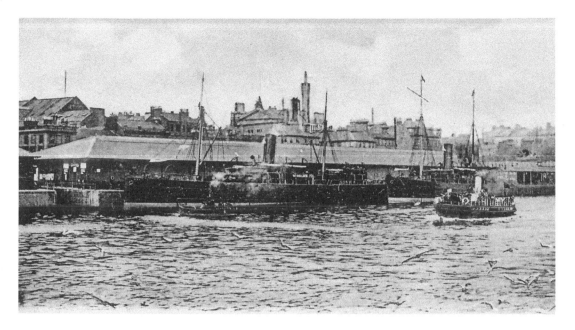

## Clyde Ships

The River Clyde boasts a long and distinguished association throughout the world in shipbuilding excellence. Generations of warships and liners have been constructed in Glasgow, including the *Queen Mary* and the *Queen Elizabeth II* (QE2). During the Second World War Glasgow shipyards were heavily relied on for the construction of naval vessels, leading to the near destruction of the Clydebank area in the Blitz of March 1941. Although the shipbuilding industry in Glasgow has declined significantly from its wartime peak, there continues to be major shipbuilders operating on the River Clyde today.

*Shipping on the Clyde, Glasgow.*

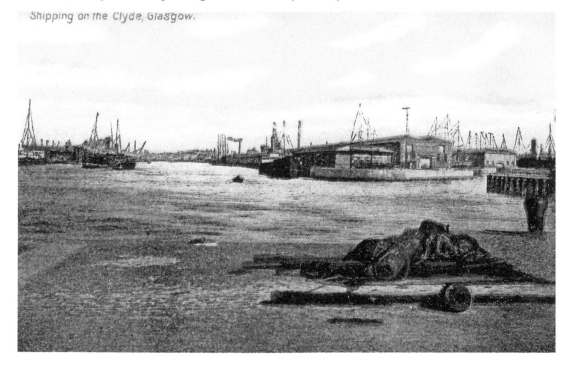

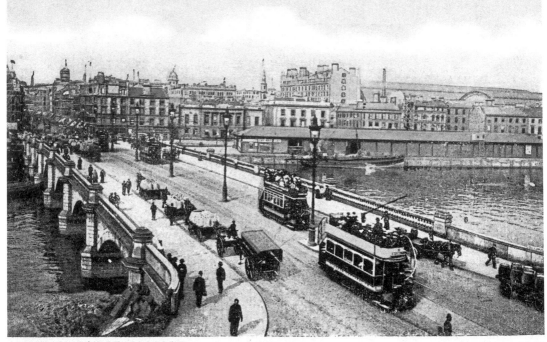

JAMAICA BRIDGE, GLASGOW

## Jamaica Bridge

Also known as Glasgow Bridge, Jamaica Street spans the River Clyde from Jamaica Street in the north to Bridge Street in the south. Named to commemorate Glasgow's long association with shipping goods to countries around the world, the original Jamaica Bridge was constructed in 1772 and has subsequently been replaced on two occasions. The second incarnation of the bridge, constructed in 1833, was the first bridge in Glasgow to be lit by electricity.

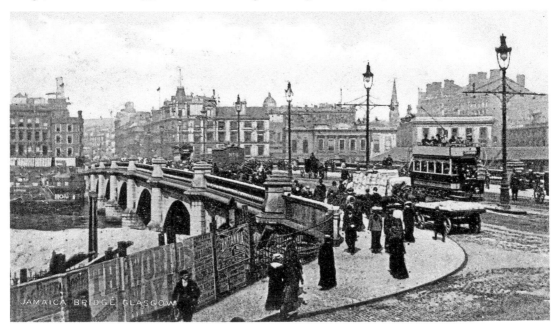

JAMAICA BRIDGE GLASGOW

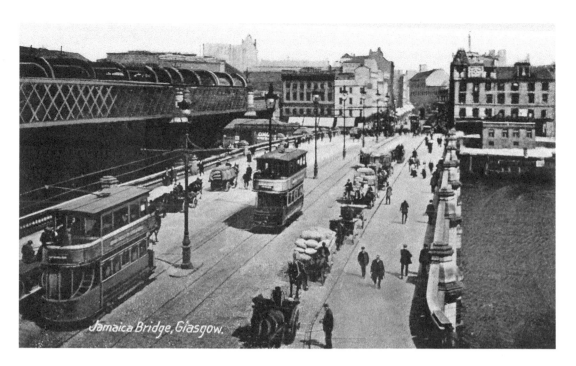

Jamaica Bridge and the Caledonian Railway Bridge

Both of these postcard images are looking towards Jamaica Street, which links Argyle Street with the Broomielaw. The bridge seen to the left of both images is the original Caledonian Railway Bridge, completed in 1878. The bridge carried four tracks across the River Clyde and linked the former St Enoch's station with destinations to the south of Glasgow. The bridge was replaced in 1905 with one that accommodated thirteen tracks – it is still in use today. The original Caledonian Railway Bridge was demolished in 1967, although the granite piers of the bridge are still visible today.

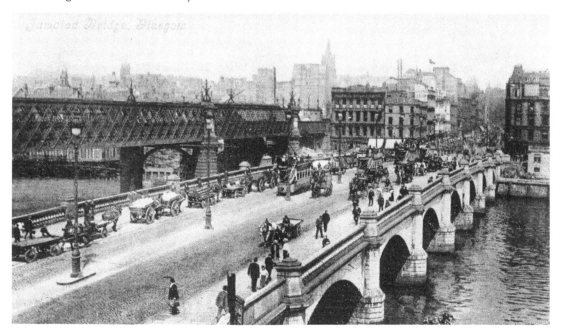

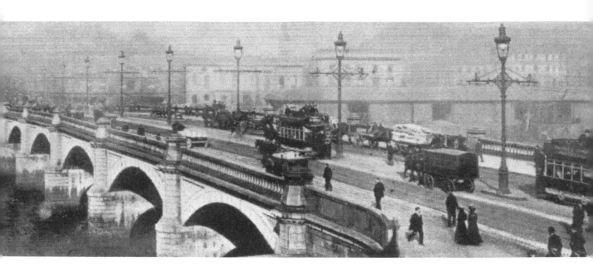

## Glasgow Bridge

The existing Glasgow Bridge, completed in 1899, was 6 metres wider than its predecessor and features expanded arches to accommodate the larger ships of the time. The current bridge maintained the previous design by Thomas Telford, an internationally renowned Scottish engineer. Thomas Telford was responsible for many feats of engineering throughout the world, including the Caledonian Canal, the Ellesmere Canal, the Menai Suspension Bridge, Dean Bridge in Edinburgh, and the Göta Canal in Sweden. Telford has been honoured numerous times since his death in 1834, with the English town of Telford, Telford College in Edinburgh, Telford Bridge in Nova Scotia, and the Borough of Telford in Pennsylvania all named after him.

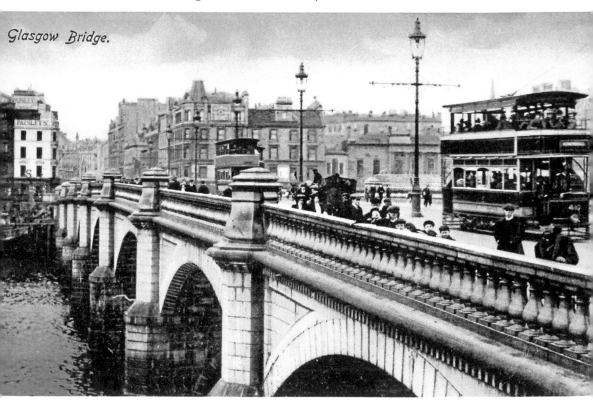

Glasgow Bridge.

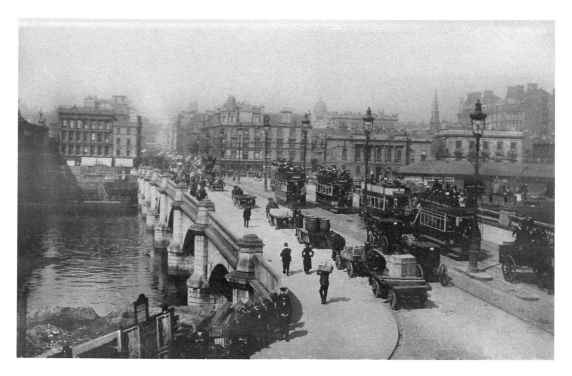

## Glasgow Bridge

These postcard images of Glasgow Bridge demonstrate just how important the bridge was in connecting the city, removing the need to use crossings further east and the reliance on ferry crossings to cross the River Clyde, particularly while the city continued to expand to the west. As of 2017, there are sixty-eight crossings over the River Clyde, including by road, rail, and on foot, from the Erskine Bridge to the north-west of Glasgow to Elvanfoot towards the south-east.

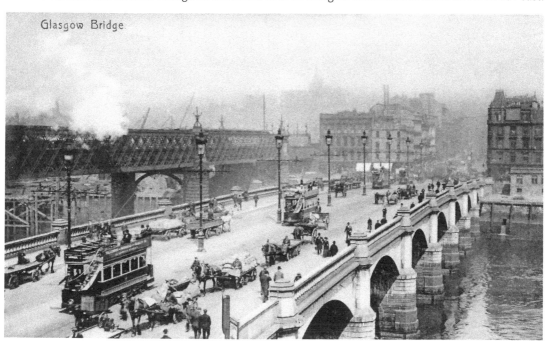

Glasgow Bridge

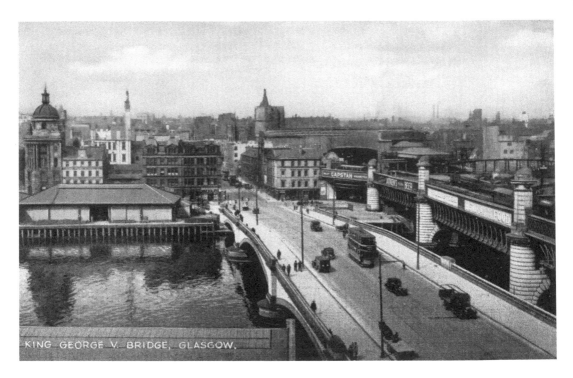

KING GEORGE V. BRIDGE, GLASGOW.

King George V Bridge

The King George V Bridge opened in 1928, with the war having delayed its planned construction from 1914. The King George V Bridge connects Oswald Street (north of the River Clyde) with Commerce Street in the Tradeston area of Glasgow, south of the river. While the bridge appears to be made from granite, it is actually constructed with concrete box girders. The bridge is located to the immediate east of the current Caledonian Railway Bridge.

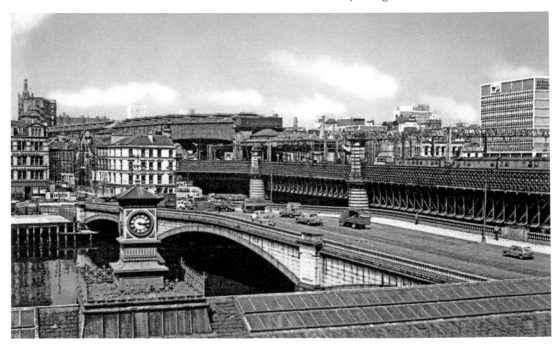

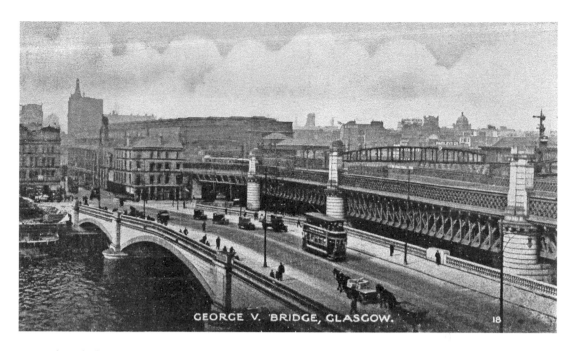

GEORGE V. BRIDGE, GLASGOW.    18

### The Clyde and the *Waverley*

Despite a long association with remarkable ships for many years, one of the most famous ships to be associated with Glasgow and the River Clyde is the *Waverley*. The *Waverley* paddle steamer, named after the novel by Sir Walter Scott, was launched in October 1946 and initially served the London & North Eastern Railway on the Firth of Clyde. A decline in business saw the *Waverley* withdrawn from service in 1973 and sold to the Paddle Steamer Preservation Society, where it was restored, maintained, and modernised and continues to sail, with summer departures from Glasgow. The *Waverley* is the last seagoing passenger paddle steamer in the world.

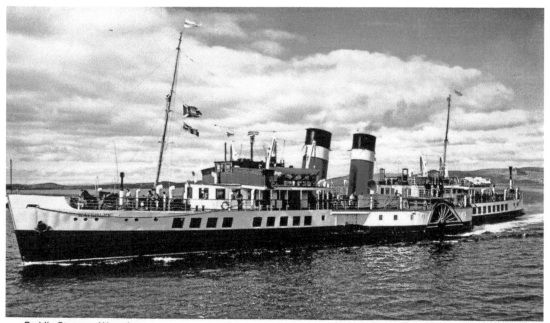

Paddle Steamer, Waverley

35

# SECTION 3
# LANDMARK BUILDINGS

Landmark buildings of Glasgow.

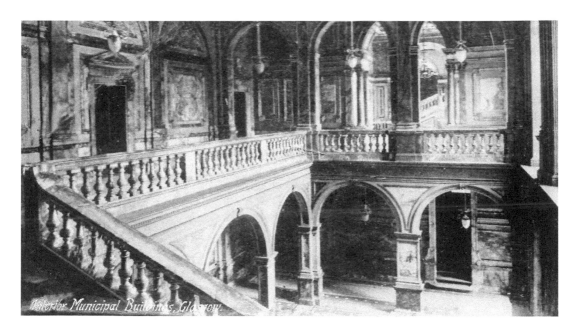

Interior Municipal Buildings, Glasgow.

## Municipal Buildings

The Municipal Buildings, or City Chambers, in George Square has been the location of Glasgow's local government since 1889, with the building having been inaugurated by Queen Victoria in 1888. The interiors of the City Chambers feature Carrara marble, alabaster, granite, and gold leaf, with the grand opulence of the entrance hall having featured in several movie productions doubling for the Vatican and the Kremlin. The City Chambers have been subsequently extended from their original construction, with additions in both John Street and George Street increasing the complex to around 14,000 square metres.

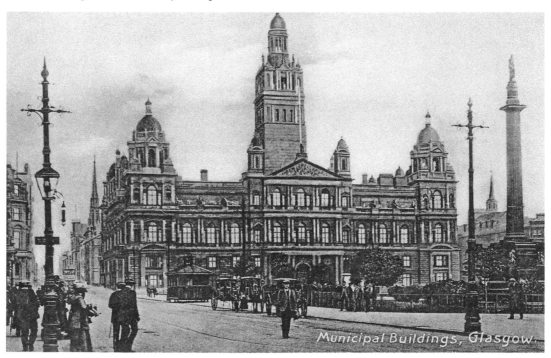

Municipal Buildings, Glasgow.

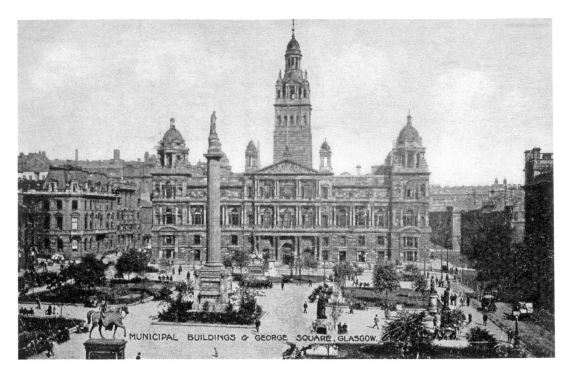

MUNICIPAL BUILDINGS & GEORGE SQUARE, GLASGOW.

## George Square

Named after George III, George Square was initially developed in 1781 as private garden space for newly constructed Georgian townhouses. George Square was eventually established as public space following a period of civil unrest, and the area has been associated with protests and demonstrations ever since. The most notable instance of this is the 1919 Black Friday rally when 90,000 protestors gathered to campaign against poor working conditions, with the Riot Act being read and armed soldiers and tanks being deployed in the area.

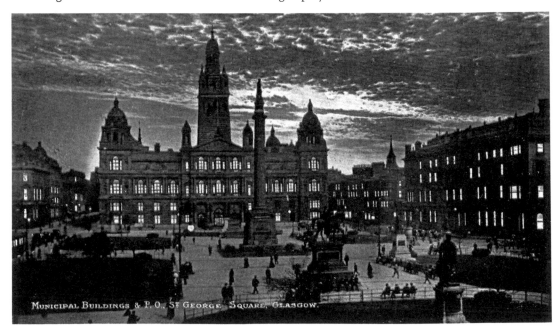

MUNICIPAL BUILDINGS & P.O., ST GEORGE SQUARE, GLASGOW.

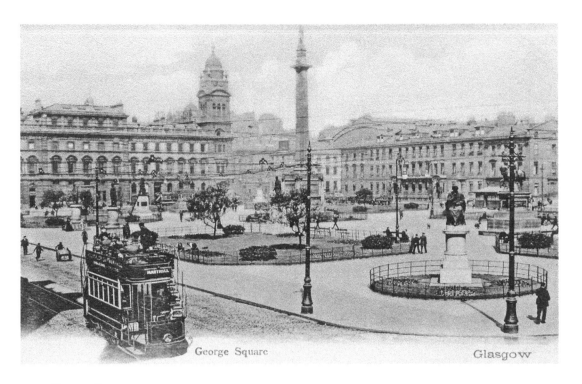

George Square Glasgow

## George Square

These postcard images show contrasting views of George Square, with the top image looking to the north-west corner, where Queen Street train station has been located since 1842, and the bottom image looking east. The most prominent of the statues in George Square is the 80-foot-tall column featuring Sir Walter Scott, with other statues commemorating Queen Victoria, Prince Albert, and Robert Burns, among others. In addition to the City Chambers along the eastern edge, George Square also featured the North British Railway Hotel and Queen Street train station in the north, the Bank of Scotland building in the west, and the General Post Office building in the south.

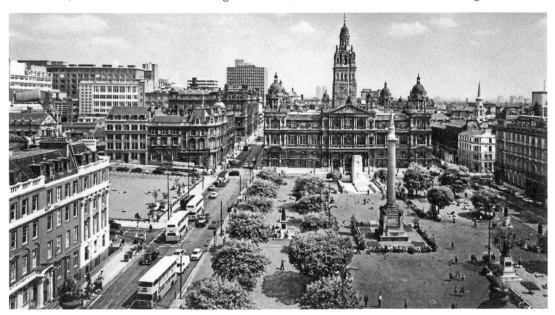

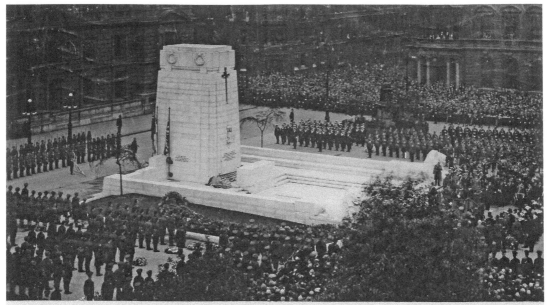

**GLASGOW CENOTAPH**
UNVEILED BY EARL HAIG, 31st MAY, 1924.

## Glasgow Cenotaph

The impressive white granite cenotaph in George Square was unveiled in 1924 by Field Marshal Earl Haig to commemorate those who lost their lives in active service during the First World War. The cenotaph is almost 10 metres tall and features a metal cross above a representation of St Mungo and the Glasgow coat of arms, with two guardant lions. An inscription referring to the loss of life in the Second World War was added in 1945. The cenotaph remains the location of Glasgow's principal annual Remembrance service in November.

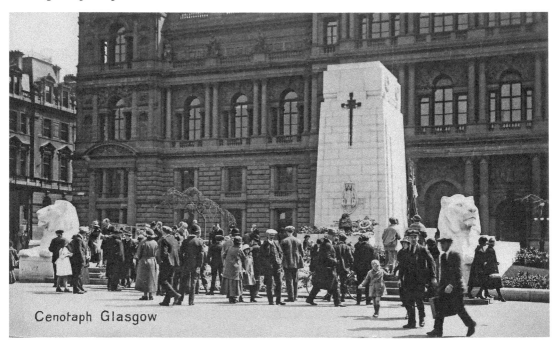

Cenotaph Glasgow

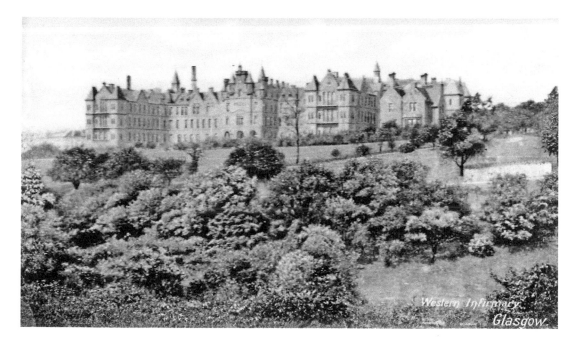

## Western and Victoria Infirmaries

Both the Western and Victoria infirmaries opened to the public in the late nineteenth century, with the Western Infirmary opening in 1874 in the west of the city and the Victoria Infirmary opening in 1890 in the south-east. The Western Infirmary was originally a teaching hospital through the neighbouring University of Glasgow, becoming part of the Glasgow Western Hospitals Board with the formation of the National Health Service in 1948. The Victoria Infirmary was named after Queen Victoria and eventually expanded to accommodate a capacity of 370 inpatient beds. Both hospitals closed in 2015 and most services were transferred to the Queen Elizabeth University Hospital in Govan.

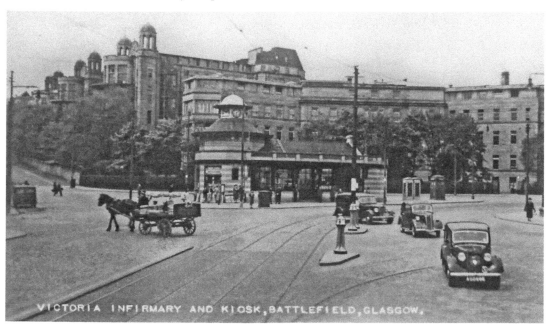

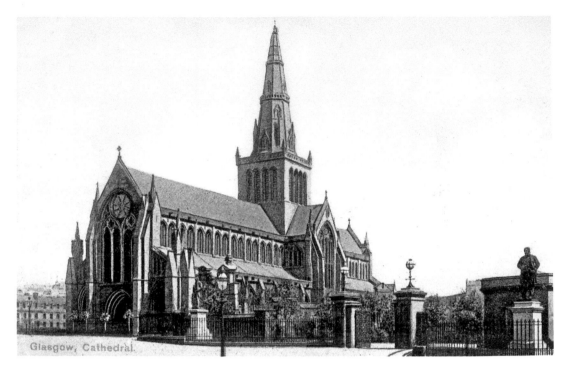

Glasgow, Cathedral.

## Glasgow Cathedral and Crypt

Consecrated in 1197, the Grade-A listed Glasgow Cathedral is one of Glasgow's most historically important buildings. Glasgow Cathedral is built on the site where St Mungo, patron saint of Glasgow, was said to have been buried, with his remains now laid to rest in the crypt of the cathedral. The shrine of St Mungo was said to be a popular destination for Christian pilgrimage until the time of the Scottish Reformation, with Glasgow Cathedral being the only cathedral on the Scottish mainland to survive that period in Scottish history.

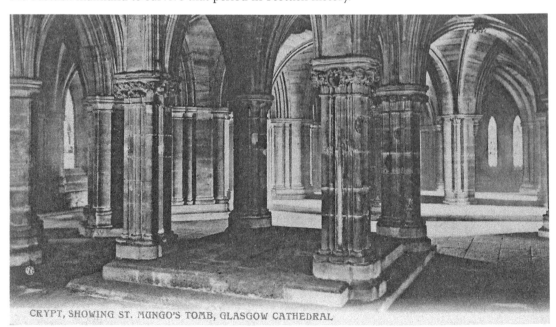

CRYPT, SHOWING ST. MUNGO'S TOMB, GLASGOW CATHEDRAL

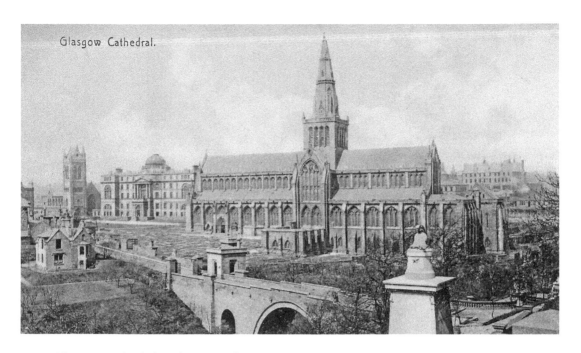

Glasgow Cathedral.

## Glasgow Cathedral and Necropolis

Prompted by the passing of the Cemeteries Act in 1832, Glasgow Necropolis opened in April 1833. The Cemeteries Act changed the law and passed the obligation of burials from parish churches to individuals and their estate. Located on a hill to the east of Glasgow Cathedral, the Necropolis hosts the remains of approximately 50,000 individuals. In addition to the Glasgow Necropolis, the city also has an Eastern Necropolis in the Parkhead area, a Western Necropolis at Lambhill, and a Southern Necropolis at Caledonia Road in the Gorbals.

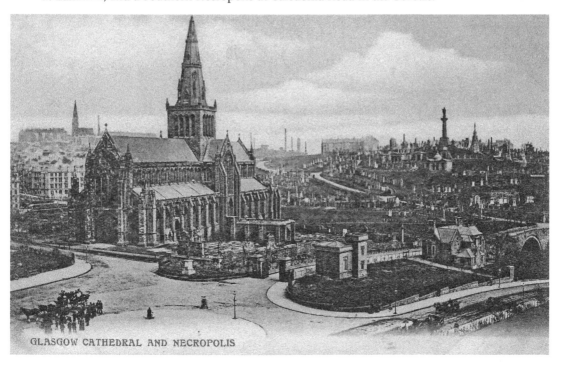

GLASGOW CATHEDRAL AND NECROPOLIS

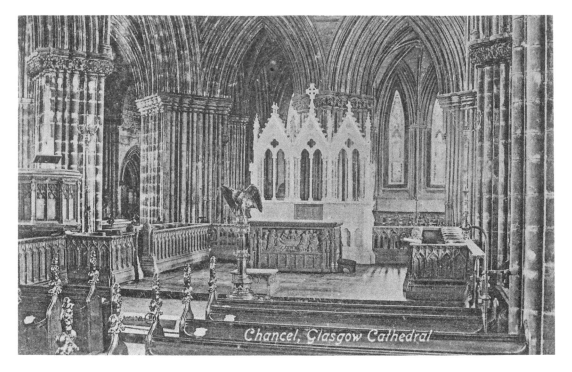

## Glasgow Cathedral Interior

The interior of Glasgow Cathedral remains a fine example of medieval architecture, with regular and significant investment ensuring the building is well maintained. In 1583 the local council, while under no obligation to do so, agreed to become responsible for repairs to Glasgow Cathedral, and the building is now under the ownership of the Crown estate and continues to have an active Church of Scotland congregation. Other cathedrals in Glasgow include St Andrew's (Roman Catholic), St Luke's (Greek Orthodox), and St Mary's (Scottish Episcopal).

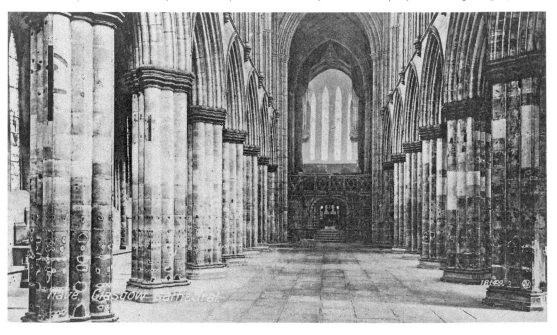

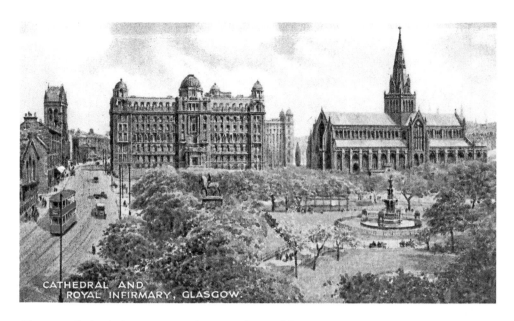

CATHEDRAL AND
ROYAL INFIRMARY, GLASGOW.

## Glasgow Cathedral Precinct and Provand's Lordship

The immediate surroundings of Glasgow Cathedral are also home to several other historic buildings including Glasgow Royal Infirmary, originally constructed in 1794 but replaced in 1914, and Provand's Lordship, the oldest house in Glasgow. Provand's Lordship was constructed in 1471 as part of the hospital of St Nicholas, and the current title of the building dates from 1562 when the lands of Provan were granted by Mary Queen of Scots to William Baillie, a canon of the cathedral. Provand's Lordship is now open to the public as a museum, with St Mungo's Museum also located nearby.

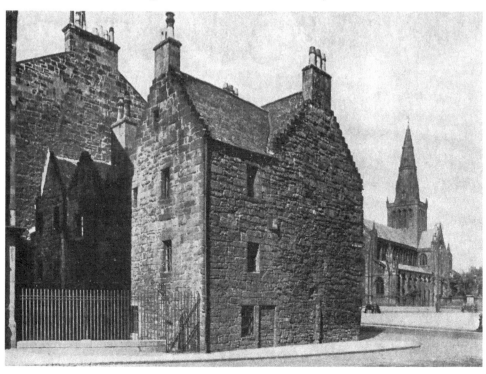

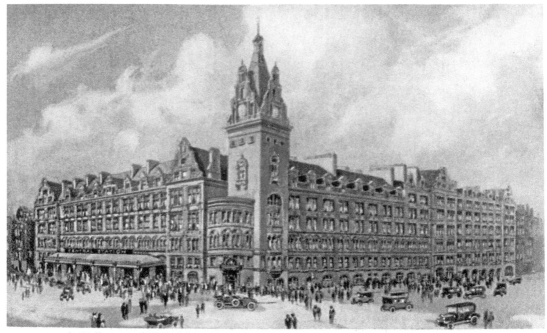

L M S.      THE CENTRAL STATION HOTEL, GLASGOW.     L M S.

Central Station and Hotel

Now the busiest train station in Scotland and one of the busiest in the UK, Glasgow Central Station originally opened in 1879 with eight platforms and a link to the former Bridge Street station, with the Central Station Hotel opening in 1883. By the turn of the twentieth century Glasgow Central was struggling to accommodate the 23 million passengers using it each year, resulting in an extensive rebuild of the station and hotel by 1907, with the station expanding to thirteen platforms following the construction of the new Caledonian Railway Bridge. The station today has a total of seventeen platforms, including two low-level platforms.

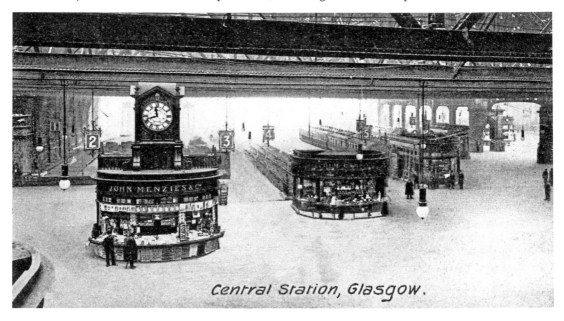

Central Station, Glasgow.

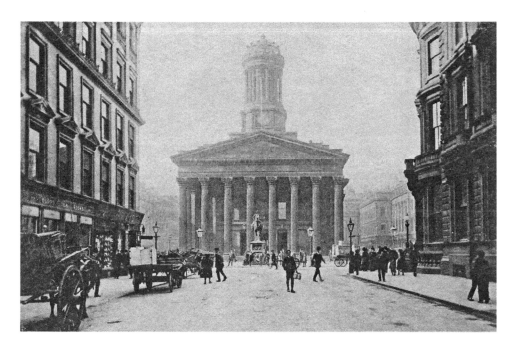

## Royal Exchange

Located between Buchanan Street and Queen Street, the Royal Exchange was originally constructed in 1778 as the mansion of William Cunninghame, local tobacco merchant and entrepreneur. The building was purchased by the Royal Bank of Scotland in 1817 but subsequently sold to the city in 1827 and converted into a commodities exchange for merchants. In 1844 the statue of the Duke of Wellington was installed outside the Royal Exchange. The statue is known today for having a traffic cone on the head of the Duke, something once discouraged by Glasgow City Council but now accepted and favoured by local people as a symbol of the character and culture of Glasgow.

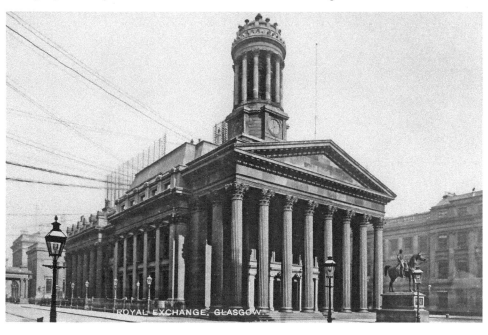

ROYAL EXCHANGE, GLASGOW

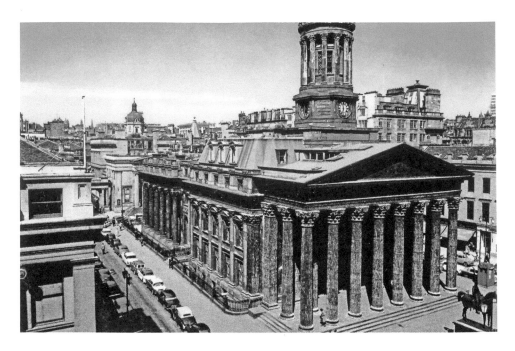

## Gallery of Modern Art and St Enoch Train Station

The former Royal Exchange building has been the home of Glasgow's Gallery of Modern Art since 1996, and has exhibited works by a wide range of artists including David Hockney and Andy Warhol. Just a few minutes' walk away from the Royal Exchange was St Enoch station, which opened in 1876 with twelve platforms serving stations throughout central Scotland and onward to destinations as far as London. The station was closed in 1966 and the station building and adjoining hotel was demolished in 1977, with the station clock now on display in Cumbernauld town centre. In 1989 construction of the St Enoch Shopping Centre was completed on the same site.

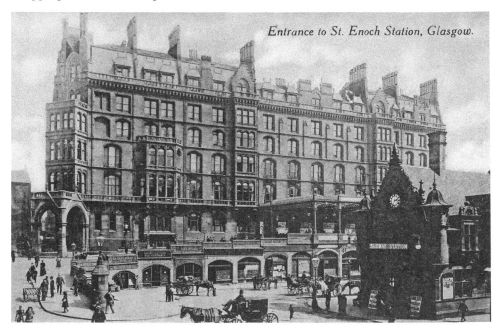

*Entrance to St. Enoch Station, Glasgow.*

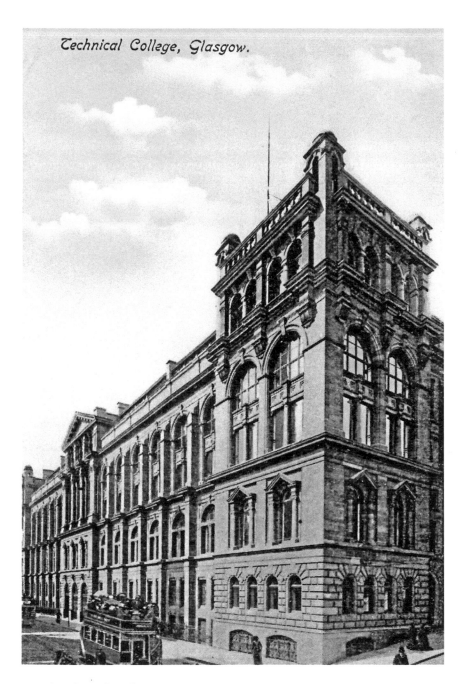

Technical College, Glasgow.

Royal Technical College

Located on George Street, the Royal College of Science and Technology was formed in 1887 and was originally known as the Glasgow and West of Scotland Technical College. A popular institution of learning in Glasgow, the building was expanded in 1903 and, after obtaining special permission from George V, the college became officially known as the Royal Technical College. The building further expanded in 1958 with further construction onto Montrose Street. The building now forms part of the University of Strathclyde campus and continues to offer educational opportunities in science and engineering.

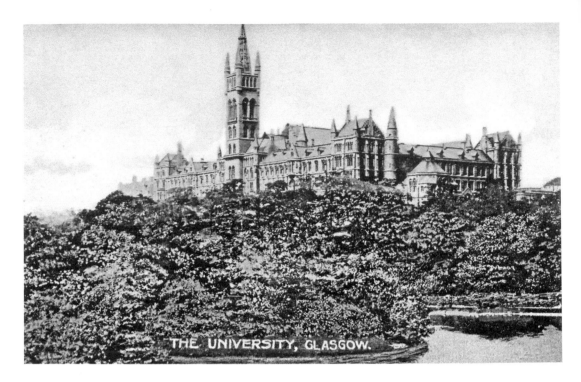

THE UNIVERSITY, GLASGOW.

## University of Glasgow

The University of Glasgow was founded in 1451 after permission was granted by Pope Nicholas V to Bishop William Turnbull to add a university to Glasgow Cathedral. The university continued to operate from buildings in High Street, close to Glasgow Cathedral, until relocating to its current premises in the west of the city in 1870. The University of Glasgow is one of the oldest universities in the world and typically has around 30,000 students each year. The bottom postcard image here shows the University of Glasgow building and how it may look to some after an evening spent in a local pub.

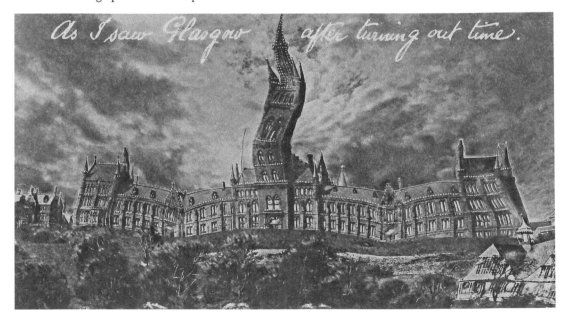

As I saw Glasgow          after turning out time.

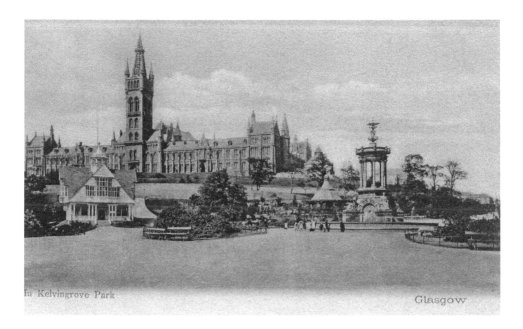

In Kelvingrove Park

Glasgow

## University of Glasgow and Kelvingrove Park

The hilltop location of the University of Glasgow offers excellent views over the nearby Kelvingrove Park and ensures the building is a prominent feature of the city skyline, with the bell tower standing at a height of 279 feet tall. The university campus now extends over much of Glasgow's west end, with buildings in the Hillhead, Woodlands, and Maryhill areas. Notable alumni of the University of Glasgow include Adam Smith, John Logie Baird, David Livingstone, John Buchan, Edwin Morgan, Nicola Sturgeon, and Gerard Butler. The bottom postcard image shows the university and the Cameronians memorial in Kelvingrove Park, erected to commemorate the service of the Cameronians (Scottish Rifles) regiment.

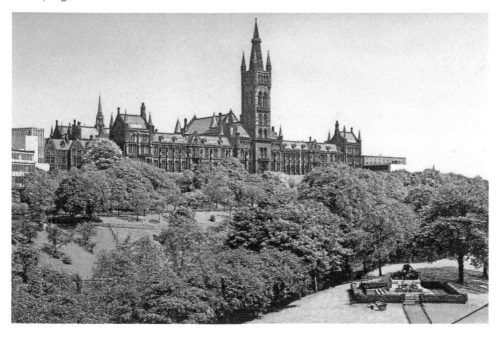

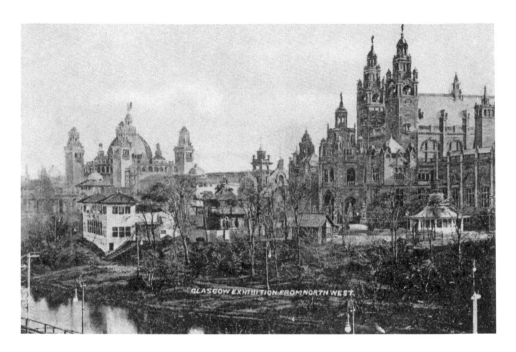

Kelvingrove and Glasgow International Exhibition, 1901

From 2 May until 4 November 1901 Kelvingrove Park was the location of the International Exhibition, with the Palace of Fine Arts becoming Kelvingrove Museum and Art Gallery. The exhibition was attended by over 11 million visitors and featured exhibitions from countries including Canada, Japan, and Russia. The specially created Saracen Fountain was subsequently relocated to Alexandra Park and two exhibition cottages from the Port Sunlight village in Merseyside remain in Kelvingrove Park today. There is a misconception that the Museum and Art Gallery building was constructed back to front, but it was always intended for the main entrance to be facing the park with the rear entrance facing onto Argyle Street.

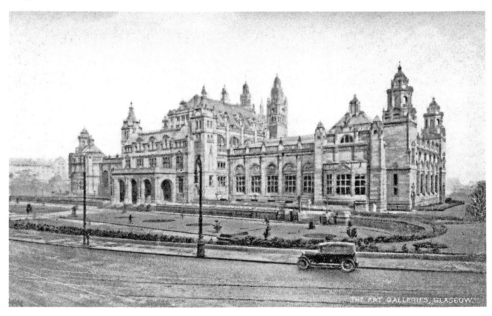

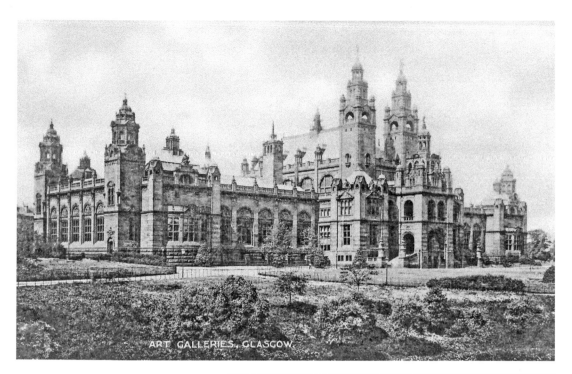

ART GALLERIES, GLASGOW.

## Kelvingrove Museum and Art Gallery

Following the 1901 International Exhibition, Kelvingrove Museum and Art Gallery opened permanently to the public in October 1902. The style of the building is typically described as Spanish baroque, and the two main towers are said to be modelled on the church of Santiago de Compostela in Spain. During the Second World War many exhibits were redistributed around the county, proving fortuitous as a bomb landed nearby in 1941 and shattered 50 tons of window glass. The building closed in 2003 for refurbishment, reopening in 2006. In 2007 there were over 2 million visitors to Kelvingrove, making it the most popular free-entry museum in the United Kingdom outside London.

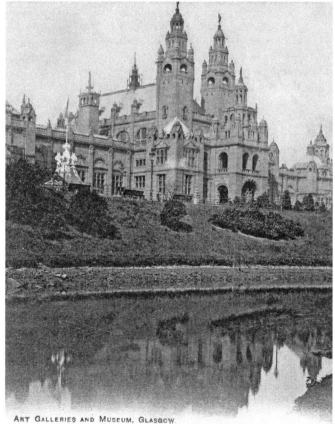

ART GALLERIES AND MUSEUM, GLASGOW.

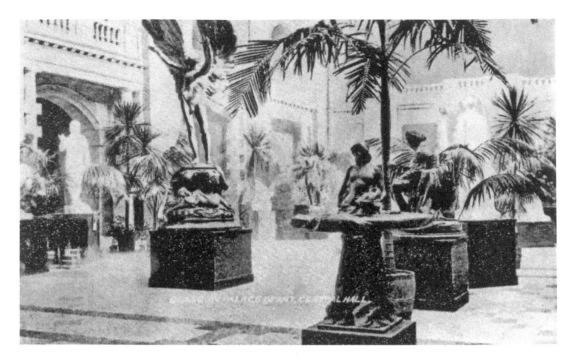

## Kelvingrove Interior

The key feature of Kelvingrove's Central Hall has always been the concert pipe organ. The organ was commissioned for the 1901 International Exhibition and has provided musical entertainment to generations of tourists and visitors. Kelvingrove Museum and Art Gallery features an impressive collection of exhibits, including artworks by world-renowned painters such as Rembrandt, Monet, Renoir, Van Gogh, and Salvador Dali, with particular recognition given to his painting of *Christ of Saint John of the Cross*.

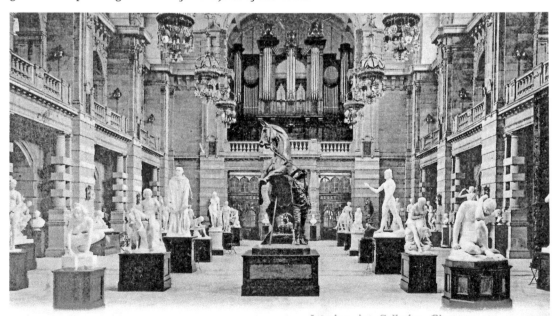

Interior, Art Galleries, Glasgow

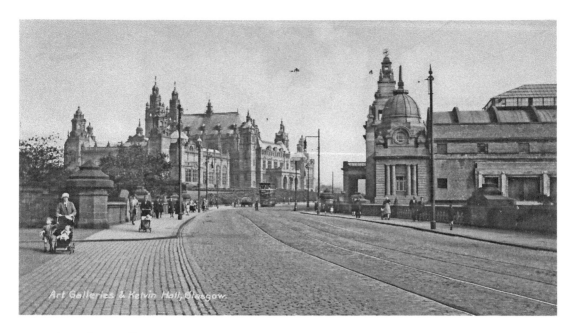

Art Galleries & Kelvin Hall, Glasgow

## The Kelvin Hall

Located adjacent to Kelvingrove Museum and Art Gallery, and also on Argyle Street, the Kelvin Hall was officially opened in July 1927 by George V. The Kelvin Hall initially opened as an exhibition venue for events including the Kelvin Hall Circus, Modern Homes Exhibitions, and musical performances by Elton John, the Kinks, Ella Fitzgerald, and Jerry Lee Lewis, although it operated as a barrage balloon factory during the Second World War. The Kelvin Hall was the location of Glasgow's Museum of Transport from 1987 until 2010, relocating to the Riverside Museum. From 2016 the Kelvin Hall reopened with collections from the Hunterian, Glasgow Museums, and the National Library of Scotland.

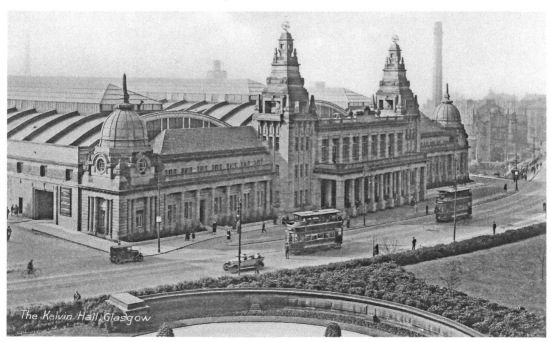

The Kelvin Hall, Glasgow

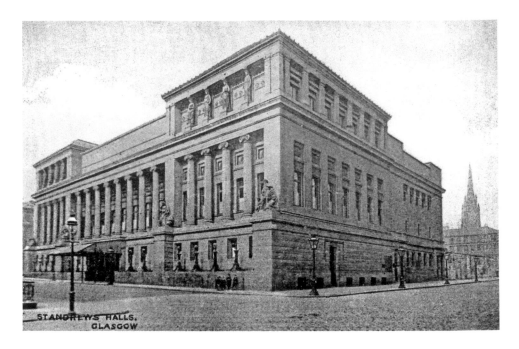

St Andrew's Halls and Mitchell Library

St Andrew's Halls opened in 1877 as a performance and function venue, with the Grand Hall having a capacity of 4,500 and acoustics said to be among the best in Europe, with the building also including several smaller halls and a ballroom. The Mitchell Library opened in 1911 on North Street at Charing Cross, and backed onto St Andrew's Halls. The Mitchell Library holds the Glasgow city archives and one of the largest Robert Burns collections in the world. In 1962 St Andrew's Halls were almost completely destroyed by fire, with only the façade of the building on Granville Street surviving, now incorporated into an extended Mitchell Library and Theatre.

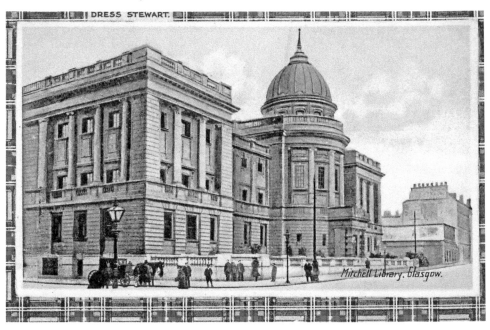

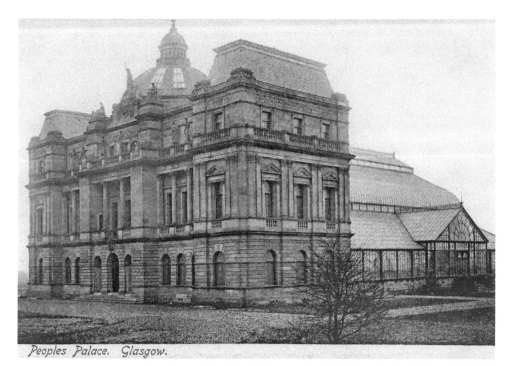

Peoples Palace. Glasgow.

People's Palace

Located on Glasgow Green, the People's Palace and Winter Gardens opened in January 1898 to provide a cultural space, principally for the people of Glasgow's east end. The People's Palace contains an extensive range of exhibits and historical artefacts detailing the social history of Glasgow, with replicas of tenement rooms, the Single End (single-roomed house), and the Steamie wash houses, and information on the history of Glasgow Green, the Doulton Fountain, and the nearby Templeton carpet factory.

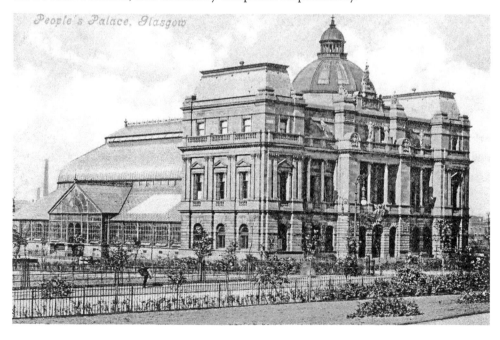

People's Palace. Glasgow

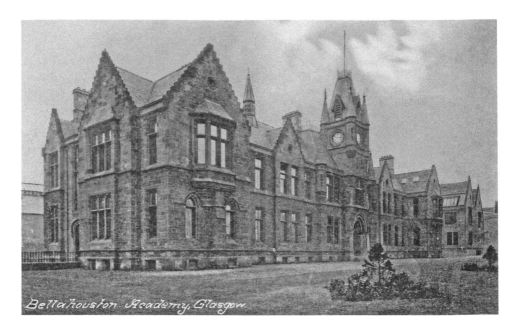

Bellahouston Academy, Glasgow.

## Bellahouston Academy and Ibrox Stadium

Bellahouston Academy first opened in 1876, but struggled financially to operate as a private school so was sold to Govan Parish School Board in 1885 for £15,000. The new Bellahouston Academy building opened in 1962, located just five minutes' walk from the original school building. Located nearby is Ibrox Stadium, home to Rangers Football Club since 1899, with the iconic red-brick façade of the main stand on Edmiston Drive constructed in 1928. The 1971 Ibrox disaster, where sixty-six people died due to a stairway crush, prompted extensive works to the stadium and the creation of three new all-seated stands. As of 2017, the capacity of Ibrox Stadium is 50,817.

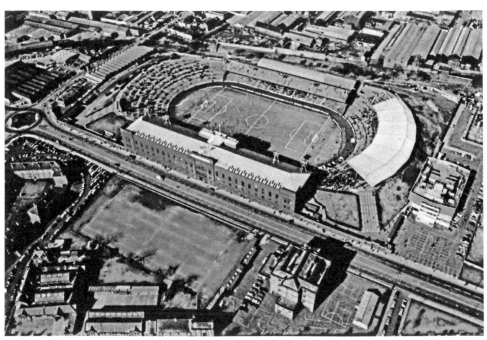

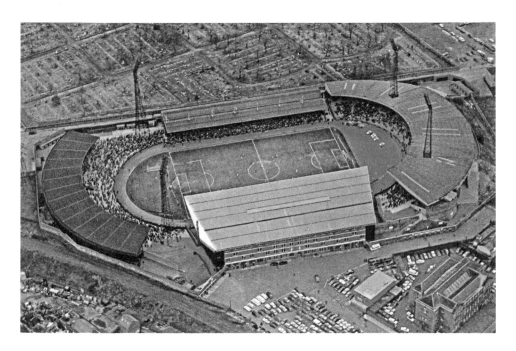

## Celtic Park and Hampden Park

Based in the Parkhead area of Glasgow, Celtic Park first opened in Janefield Street in 1892. With clubs required to have an all-seater stadium by August 1994, there were proposals for Celtic to move to a new stadium, with permission granted in Cambuslang; however, following significant financial investment, Celtic Park was redeveloped to a capacity of 60,411. Hampden Park, located in the Mount Florida area of Glasgow, is headquarters to the Scottish Football Association and the home ground for Scotland's national football team and Queen's Park Football Club. The postcard below shows Hampden Park during the Scotland versus England match on 4 April 1908, which had an attendance of 121,452.

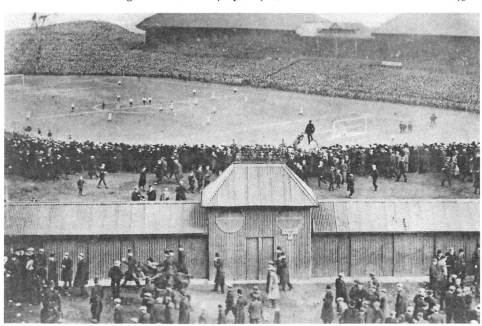

# SECTION 4
# UP SAUCHIE, DOON BUCKIE, ALANG ARGYLE

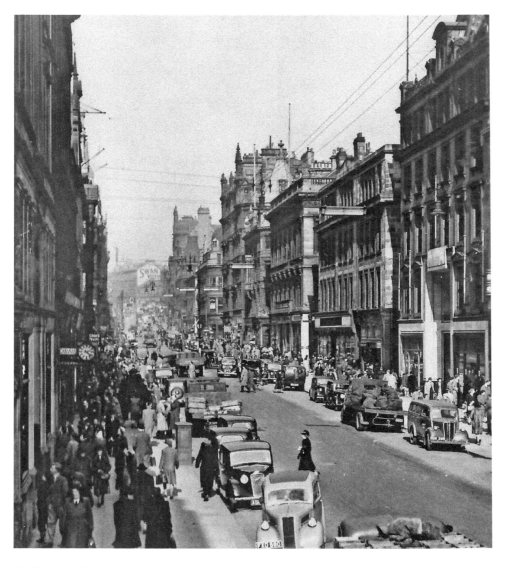

Buchanan Street.

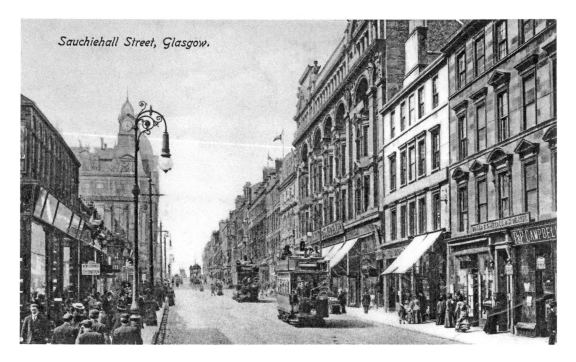

*Sauchiehall Street, Glasgow.*

## Sauchiehall Street

Best known as one of Glasgow's main shopping streets, Sauchiehall Street is named from 'Sauchie Hauch', meaning 'abounding in willows and a low-lying riverside meadow'. Sauchiehall Street is 1.5 miles long, from Buchanan Street at the Buchanan Galleries Shopping Centre until it meets Argyle Street, close to Kelvingrove Museum and Art Gallery. Originally Sauchiehall Street continued east to meet Parliamentary Road but, following the construction of Buchanan Street bus station and eventual construction of Glasgow Royal Concert Hall, the remaining section of the former Parliamentary Road was realigned and renamed Killermont Street. These postcard images were taken from the Hope Street intersection and date from around 1908.

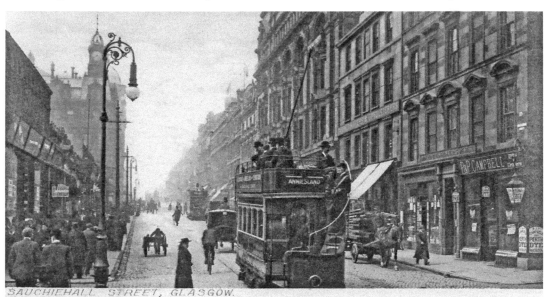

SAUCHIEHALL STREET, GLASGOW.

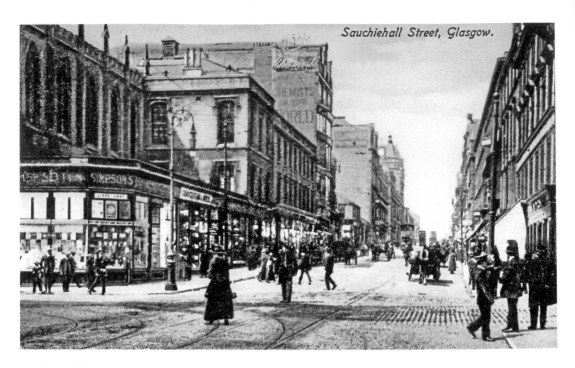

Sauchiehall Street, Glasgow.

## Sauchiehall Street

Both these postcard images look west along Sauchiehall Street towards Charing Cross, with the top image taken at the intersection with Renfield Street – part of the former Renfield Street United Free Church is visible on the left. The bottom postcard image has moved closer to the junction with Hope Street, with the former Royal Hotel visible on the right, formerly called the Osborne Hotel. The Osborne Hotel was a temperance hotel, where alcohol was strictly prohibited.

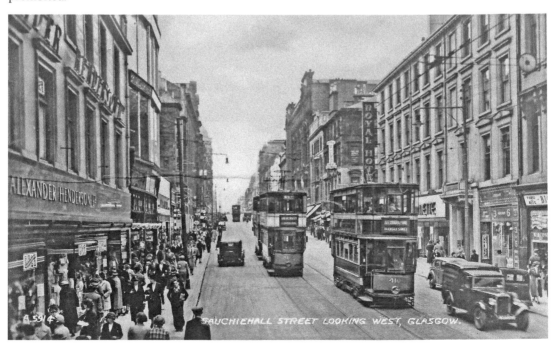

SAUCHIEHALL STREET LOOKING WEST, GLASGOW.

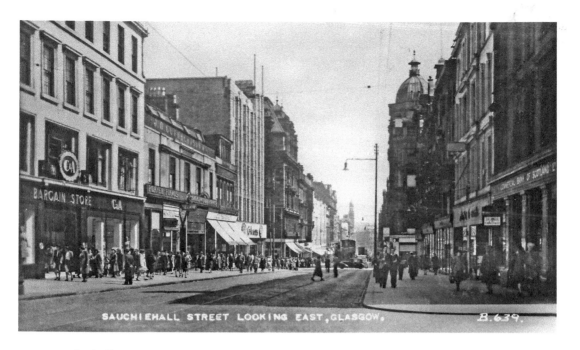

## Sauchiehall Street

Looking east on Sauchiehall Street from the junction with Rose Street, now the edge of the pedestrianised area, these postcard images capture the popularity of Sauchiehall Street and the bustling crowds. The domed building visible on the right of both postcard images, at the Sauchiehall Street junction with West Campbell Street, was demolished and became the location of the former Sauchiehall Shopping Centre. On the right of the bottom postcard image is the white façade of Kate Cranston's Willow Tearooms, originally opened in 1903. The Willow Tea Rooms were designed in their entirety by Charles Rennie Mackintosh and his wife Margaret.

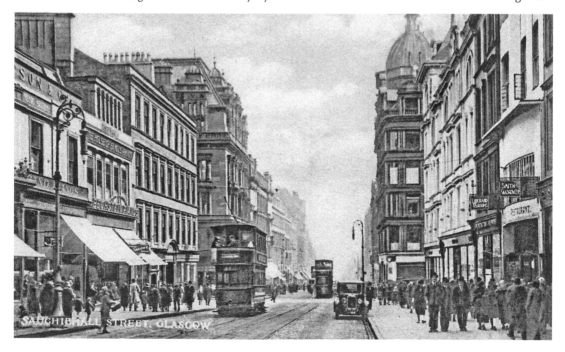

63

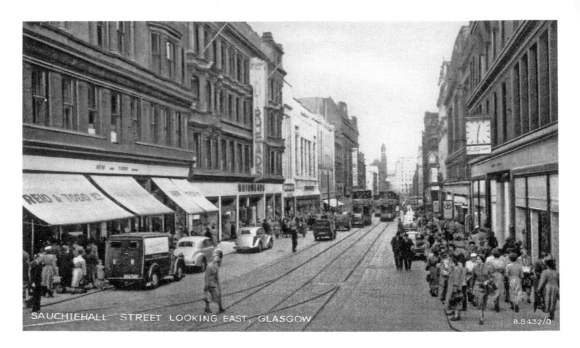

SAUCHIEHALL STREET LOOKING EAST, GLASGOW.    8.8432/0

## Sauchiehall Street

These postcard images were captured from similar locations – at the junction with Cambridge Street on the left and West Campbell Street on the right – looking east towards Buchanan Street. In the top image the Gaumont Cinema is visible, which originally opened in 1910, with the façade of the cinema becoming the main entrance for the Savoy Shopping Centre. The bottom postcard image is dated 1923 and shows the range of businesses occupying the building on the left, at the corner of Sauchiehall Street and Cambridge Street, including Reid & Todd leather goods, J. Karter & Co. wholesale furriers, the Scottish Society for the Prevention of Vivisection, and Rodmure School of Dress.

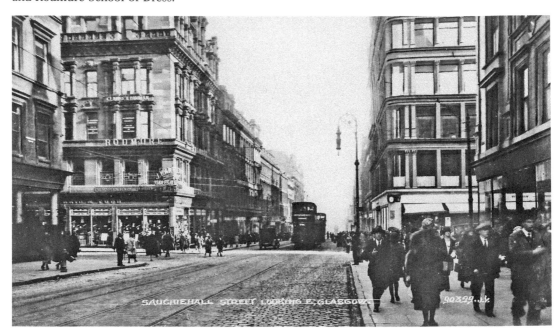

SAUCHIEHALL STREET LOOKING E. GLASGOW.    90899.J.V.

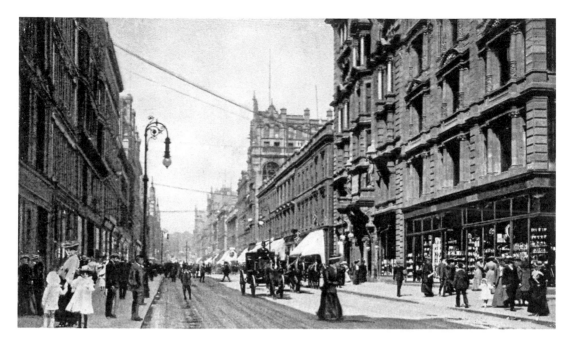

## Buchanan Street

These postcard images look north on Buchanan Street, towards Sauchiehall Street and Parliamentary Road, with the top postcard image dated around 1911. Buchanan Street was named after Andrew Buchanan, a wealthy tobacco merchant who owned much of the land at between Argyle Street and Gordon Street. Buchanan Street is half a mile long and is pedestrianised over its full length – from Argyle Street in the south to Sauchiehall Street in the north. In 2002 a statue of Donald Dewar, former First Minister of Scotland, was unveiled in Buchanan Street by Prime Minister Tony Blair and was located close to the steps of the Royal Concert Hall.

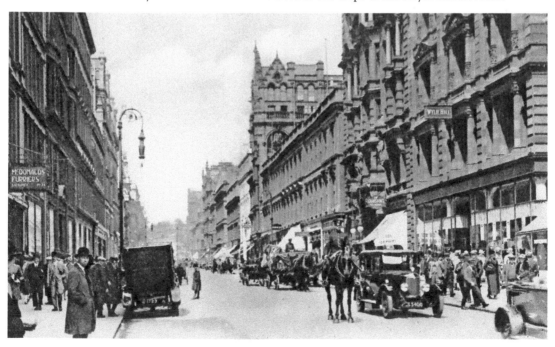

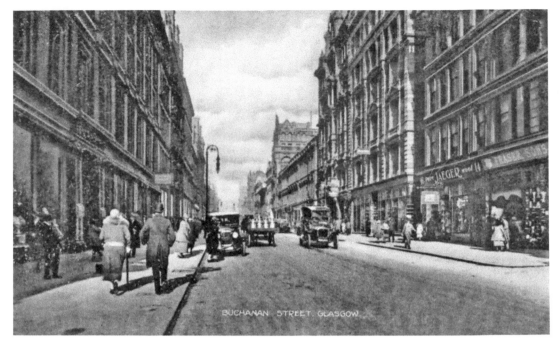

BUCHANAN STREET, GLASGOW

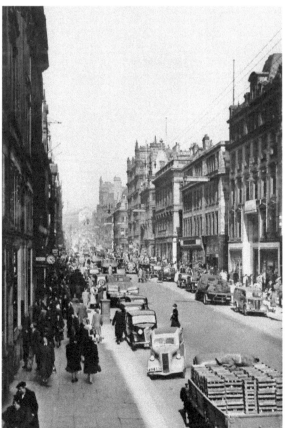

BUCHANAN STREET, GLASGOW

## Buchanan Street

While best known as one of Glasgow's main shopping streets, Buchanan Street has been prominently associated with transportation for many years. In 1849 the Caledonian Railway constructed Buchanan Street railway station on the current site of Glasgow Caledonian University. The station was closed in 1966 and demolished in 1967. Buchanan bus station, Glasgow's main bus and coach station, opened in 1977 and is located to the north of Buchanan Street, although with no entrance or exit now on Buchanan Street following the construction of the Buchanan Galleries Shopping Centre. Both these postcard images look north towards the junction of Buchanan Street and St Vincent Place.

## Buchanan Street

These postcard images, captured close to the Buchanan Street junction with Gordon Street, look north and show more clearly the spire of St George's Tron Church, located in the former St George's Place, now Nelson Mandela Place. St George's Tron Church opened in 1808 as St George's Parish Church and was extensively refurbished in 2009. St George's Place was renamed Nelson Mandela Place in 1986 in support of the South African and in protest of his incarceration in prison. In 1993 Nelson Mandela visited Glasgow, having been awarded the keys to the city in 1981 and an honorary doctorate from Glasgow Caledonian University in 1990.

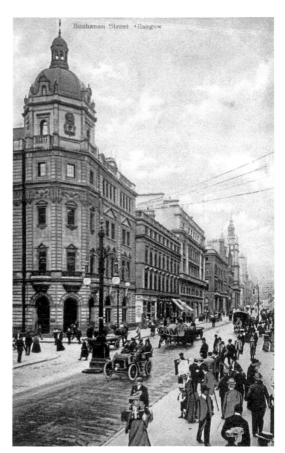

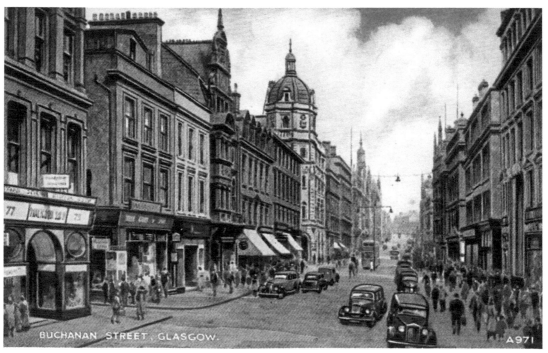

BUCHANAN STREET, GLASGOW.

A971

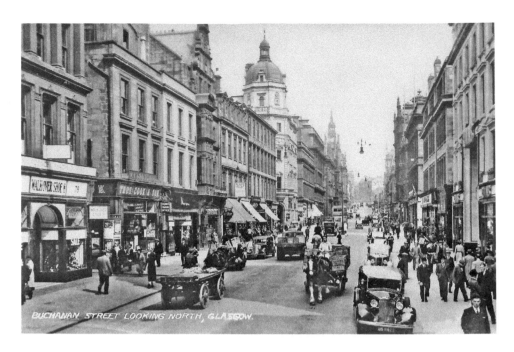

Buchanan Street

In 1947 this postcard of Buchanan Street was posted home to Udny in Aberdeenshire, describing the experiences of a visit to Glasgow. In August 1947 the British Home Fleet visited Glasgow and included the HMS *Duke of York*, aircraft carrier HMS *Illustrious*, HMS *Anson*, and HMS *Howe*, constructed on the River Clyde at Fairfield Shipyards and former flagship of the British Pacific Fleet. While in Glasgow, the writer also saw the 1942 movie *Hatter's Castle*, starring Robert Newton, Deborah Kerr, and James Mason, depicting the Tay Bridge Disaster, and saw a performance by the popular Scottish entertainer Harry Gordon.

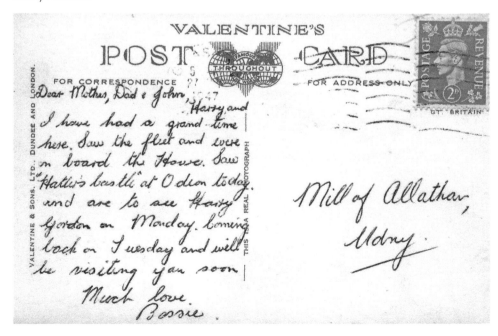

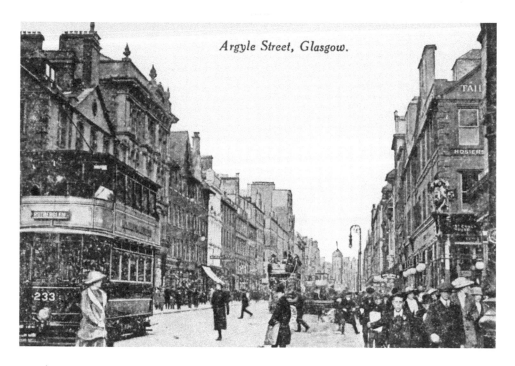

*Argyle Street, Glasgow.*

## Argyle Street

The longest street in the city centre at over 2 miles long, Argyle Street stretches from Trongate in the east to Dumbarton Road in the west. Argyle Street includes a partially pedestrianised shopping area, the St Enoch Shopping Centre and the former train station, passing underneath Glasgow Central Station and the Kingston Bridge, crossing the Anderston and Finnieston areas of Glasgow, and terminating close to Kelvingrove Museum and Art Gallery. These postcard images are looking east towards the Trongate.

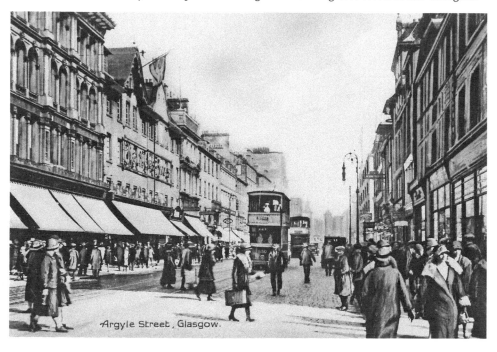

*Argyle Street, Glasgow.*

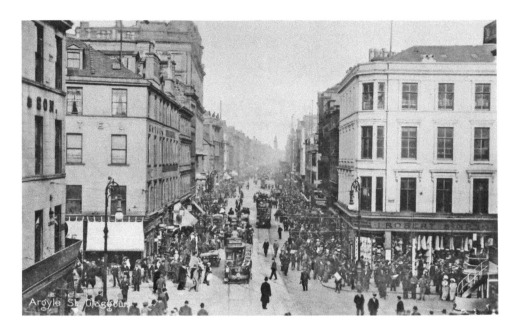

## Argyle Street

These postcard images look east along Argyle Street and show the crossroads junction where Argyle Street meets Union Street and Jamaica Street. Argyle Street is named for Archibald Campbell, 3rd Duke of Argyll, who laid in state in the Highland Society's House after his death in 1761, with the street renamed in his honour. These postcard images were captured from an elevated position at Glasgow Central Station, with the bottom image dated to 1903 when this particular postcard was sent to Nova Scotia.

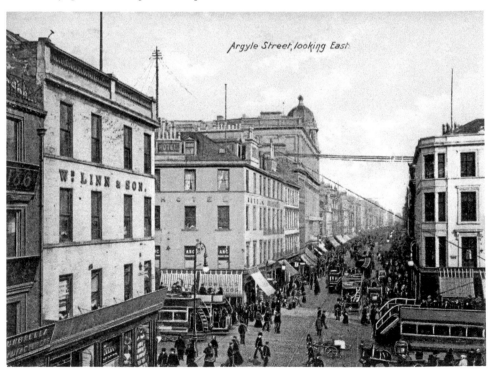

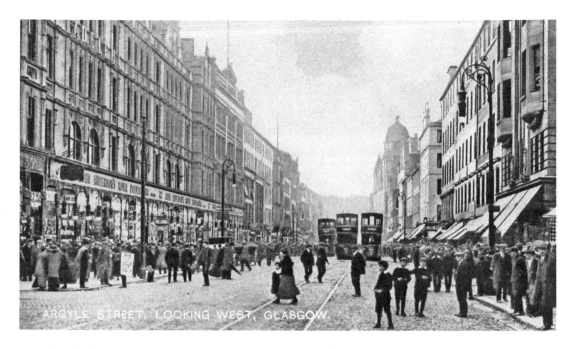

ARGYLE STREET, LOOKING WEST, GLASGOW.

## Argyle Street

Captured close to Argyle Street's junction with Virginia Street, these postcard images look west towards Glasgow Central Station, with the domed building to the right of both images marking the junction with Buchanan Street. Argyle Street was previously known as Dumbarton Road, now meeting the existing Dumbarton Road at the River Kelvin, and also Wester Gate. Argyle Street was renamed following the demolition of the West Port in 1751 to expand the city to the west.

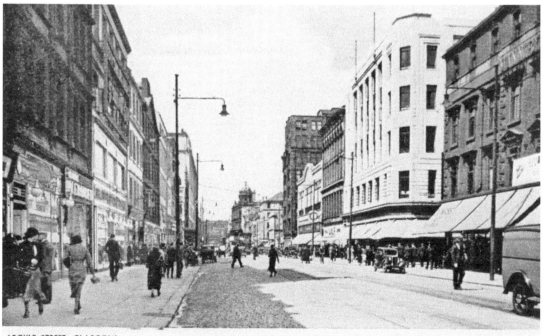

ARGYLE STREET, GLASGOW

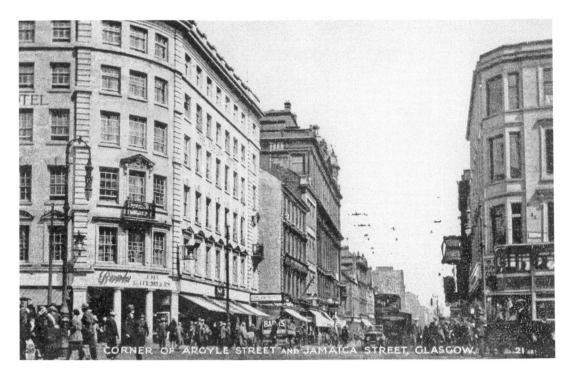

CORNER OF ARGYLE STREET AND JAMAICA STREET, GLASGOW.

Argyle Street and Royal Visit, 1907

On 24 April 1907 the below postcard image was captured of the royal carriage on Argyle Street. This was during a royal visit to Glasgow by the Prince and Princess of Wales, the future George V and Queen Mary. To the right of the below postcard image is Morrison's Court, home of Sloans, the oldest bar and restaurant in Glasgow, originally opened in 1797. Twice a week, a stagecoach would leave from Morrison's Court bound for Edinburgh. The journey would take five hours and cost 9s.

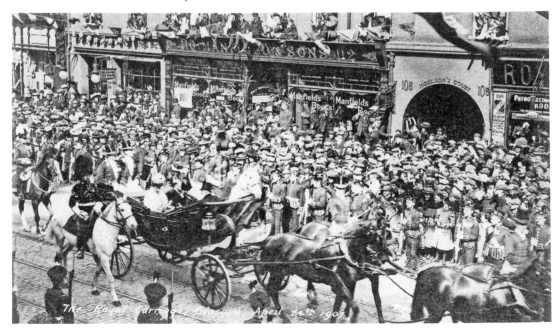

The Royal Carriage, Glasgow, April 24th 1907

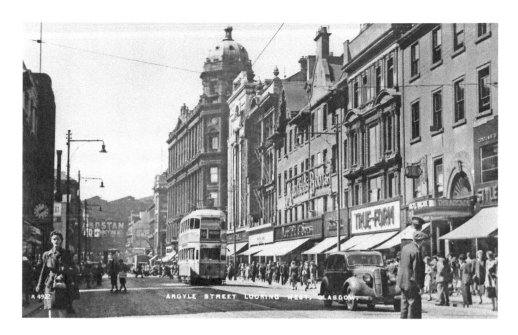

## Hielanmans' Umbrella

The glass-walled bridge carrying Glasgow Central Station's platforms over Argyle Street is most commonly known by local people as the Hielanmans' Umbrella. The term originates from the relocation of many Scottish highlanders to Glasgow for better prospects of employment and prosperity, and their favoured meeting place was under the bridge. The name was also a good fit for the typically wet weather experienced in Glasgow, particularly in winter, and the use of the bridge for shelter. The prominent location of the bridge made it an ideal spot for advertising, typically by tobacco brands, although the refurbishment of the bridge in 1998 resulted in it no longer being used for advertising.

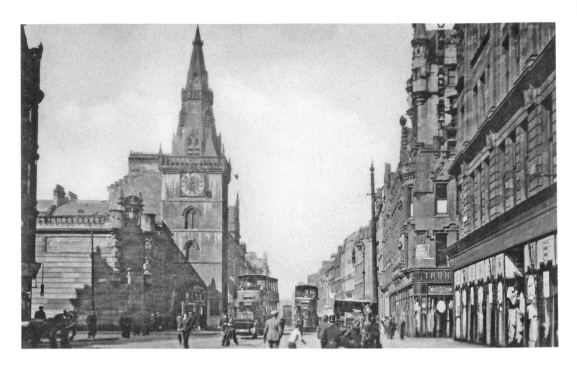

## Trongate and the Tron Theatre

Trongate is one of the oldest streets in Glasgow with origins in the mid-sixteenth century. The most prominent feature of Trongate is the clock tower of the former Tron Church, constructed in 1795, although the former church has been extensively redeveloped and rebranded as the Tron Theatre since 1980. Trongate has suffered a decline in popularity in recent years following the closure of the former Weisfelds department store (originally Goldbergs) in 1994 and the subsequent demolition of the building in 2013.

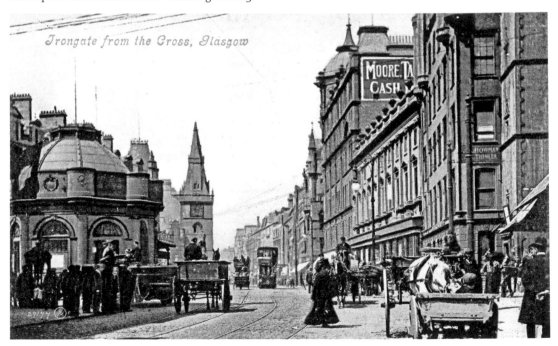

# SECTION 5

# AROUND THE CITY

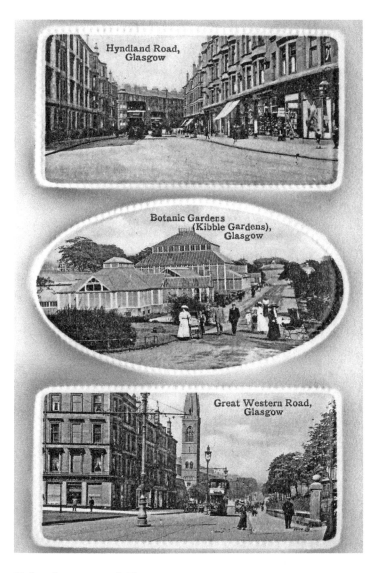

Sights from around Glasgow.

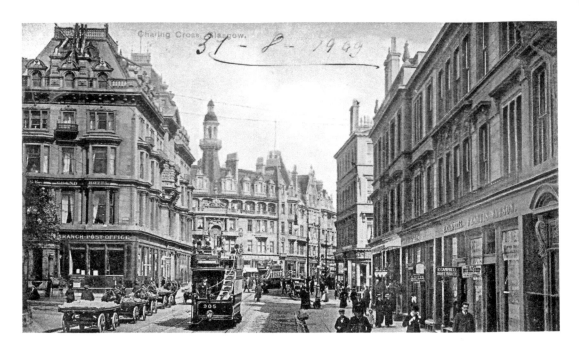

## Charing Cross

The Charing Cross area of Glasgow marks the intersection of St George's Road, Woodlands Road, North Street, Sauchiehall Street, Newton Street, Berkeley Street and Bath Street, along with the M8 motorway, which passes underneath. The tower building in the centre of both pictures is the Charing Cross Mansions, a red sandstone tenement building. Construction of the Charing Cross Mansions was completed in 1891, with the building located on the corner of Sauchiehall Street and Newton Street.

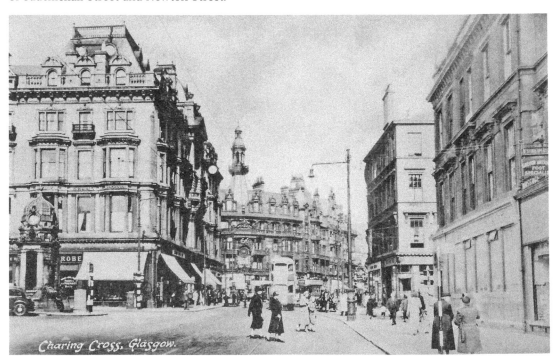

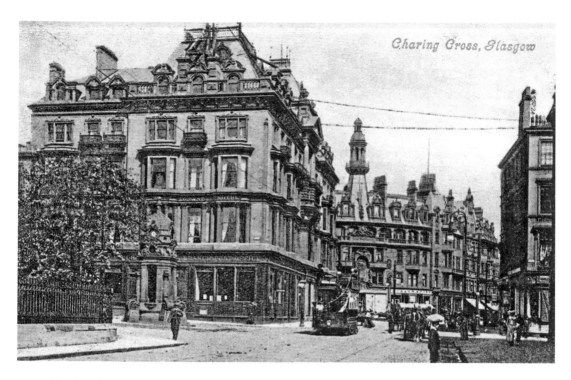

## Charing Cross

The fountain seen on the left of the above picture is the Cameron Memorial Fountain. The fountain was constructed in remembrance of Sir Charles Cameron, former editor of the *North British Daily Mail* from 1864 and MP for Glasgow from 1874 until 1900. The memorial survives today and is still located at Charing Cross, at the junction of Woodside Crescent and Sauchiehall Street, although the surrounding area has been significantly redesigned and redeveloped.

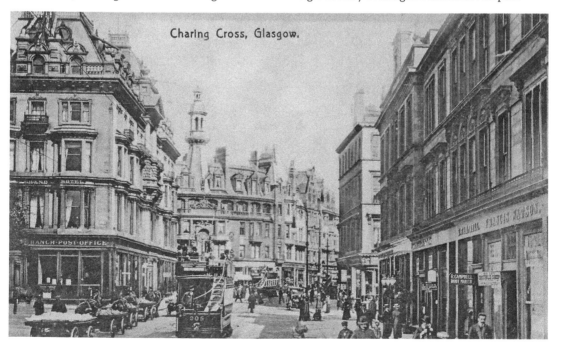

Charing Cross, Glasgow.

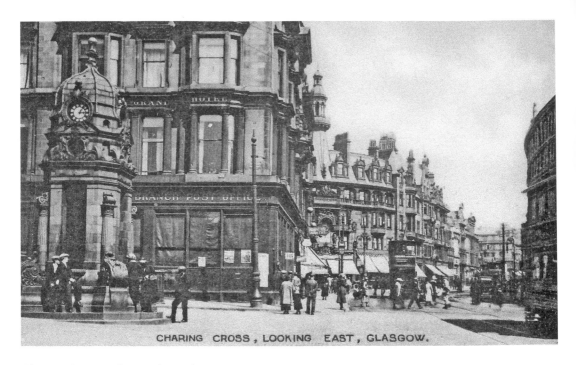

CHARING CROSS, LOOKING EAST, GLASGOW.

Charing Cross and Grand Hotel

On the left of both of these postcard images is the former Grand Hotel building. The Grand Hotel at Charing Cross opened in 1882 and was considered one of the finest hotels in Glasgow, also accommodating a number of shops and a post office. The entire area saw extensive redevelopment when plans were approved for a new motorway network in 1962, with the Grand Hotel demolished in 1969. The Charing Cross section of the M8 motorway was completed in 1972.

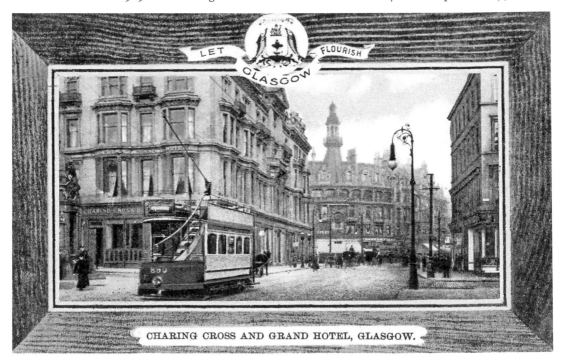

CHARING CROSS AND GRAND HOTEL, GLASGOW.

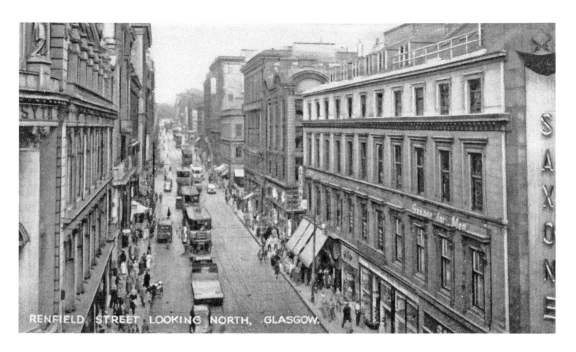

RENFIELD STREET LOOKING NORTH, GLASGOW.

## Renfield Street

These postcard images look north on Renfield Street from the junction with Gordon Street, towards Sauchiehall Street and Renfrew Street. Both Renfield Street and Renfrew Street were named by former landowner Archibald Campbell after his estate of Renfield in Renfrew. Both postcard images show the Saxone shoe store on the right, opposite Forsyth's costumiers, with the large signage being so prominent that the junction of Renfield Street and Gordon Street became known as Saxone Corner.

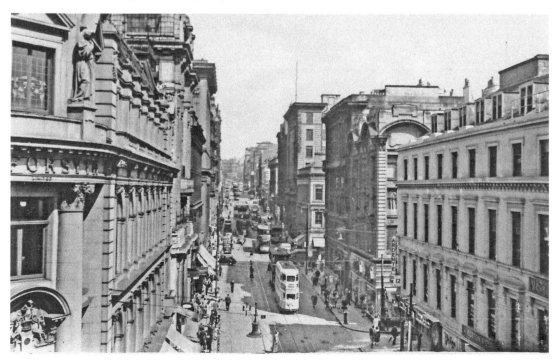

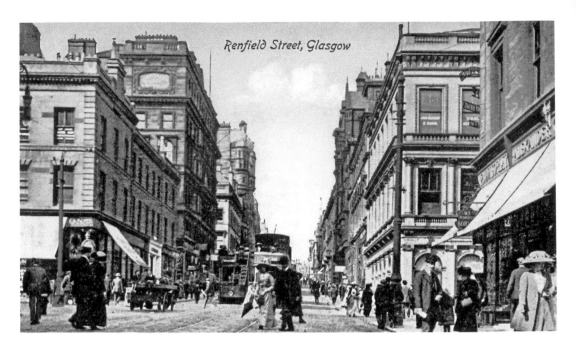

## Renfield Street

Looking north at the Renfield Street junction with St Vincent Street, the building seen on the left of both postcard images is the B. Anderson tobacco and cigar store. This building would later be replaced in 1927 by the headquarters of the Union Bank of Scotland. Further north on Renfield Street is the former Odeon Cinema building – which originally opened as the Paramount Theatre in 1934 and closed in 2006 – and the Pavilion Music Hall, which opened in 1904.

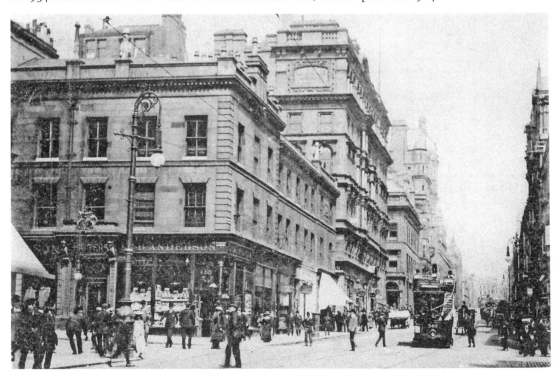

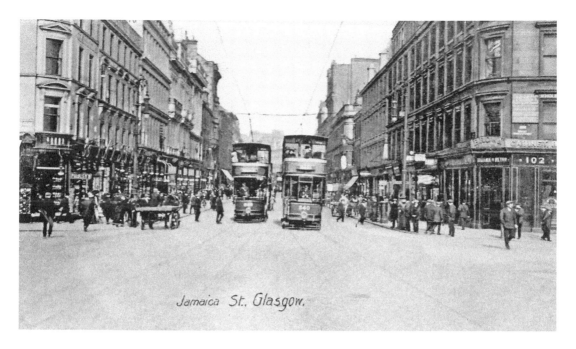

Jamaica St. Glasgow.

## Jamaica Street

Named along with the Jamaica Bridge for Glasgow's close trade association with the Caribbean, the top postcard image here looks north on Jamaica Street at the junction with Broomielaw and Clyde Street, taken from Jamaica Bridge. The corner stores seen here are Paisley's Tailors on the left, on Broomielaw Corner, and James Brown's furniture outlet on the right at Clyde Street. The below postcard image, while labelled as Jamaica Street, shows the junction of Renfield Street and St Vincent Street, with Jamaica Street typically seen as the area between Argyle Street and the Broomielaw.

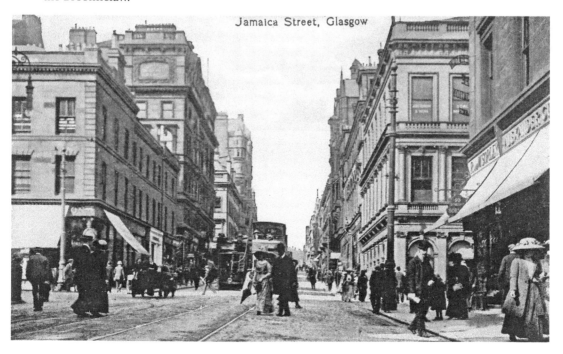

Jamaica Street, Glasgow

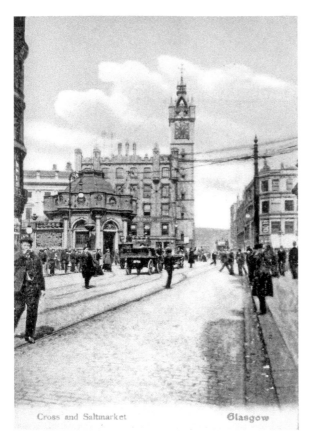

Cross and Saltmarket      Glasgow

## Glasgow Cross

Located at the junctions of High
Street, Saltmarket, Trongate,
Gallowgate, and London Road,
Glasgow Cross features one of the
oldest buildings in Glasgow, with the
Tolbooth Steeple constructed in 1625.
The steeple is all that remains of the
Tolbooth buildings, with the buildings
demolished in 1921 and replaced by
the Mercat Cross building in 1929.
Glasgow Cross and the Saltmarket
were the location of public hangings
in Glasgow, with the last public
execution carried out in 1865.

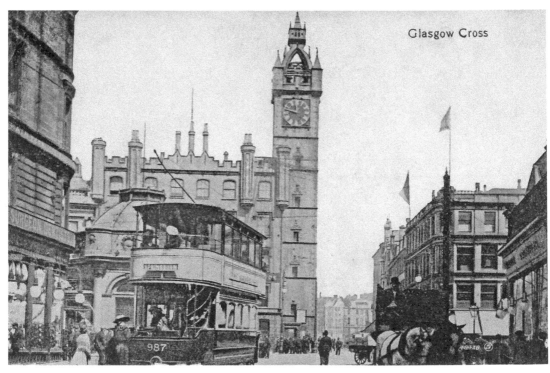

Glasgow Cross

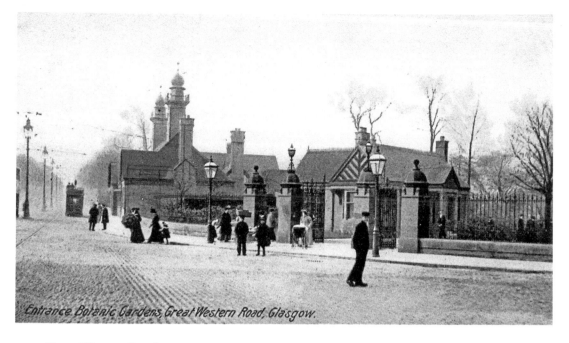

Entrance Botanic Gardens, Great Western Road, Glasgow.

## Great Western Road

Stretching for over 10 miles from St George's Cross to Bowling in the west, Great Western Road was constructed following an Act of Parliament in 1836 to create a toll road from Anniesland. These postcard images look east from the junction with Byres Road on the left and Queen Margaret Drive on the right. The entrance to the Botanic Gardens can be seen in both images, with the towered building in the centre of both images showing the former Botanic Gardens railway station, which closed in 1939, with the station building demolished in 1970 following a devastating fire.

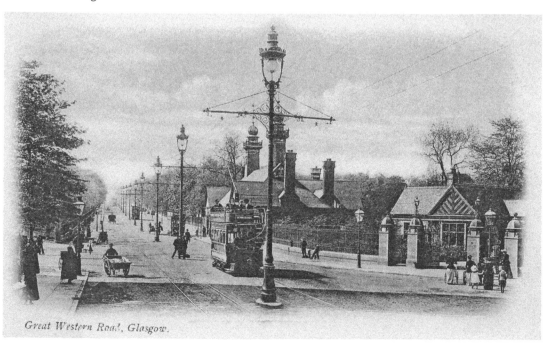

Great Western Road, Glasgow.

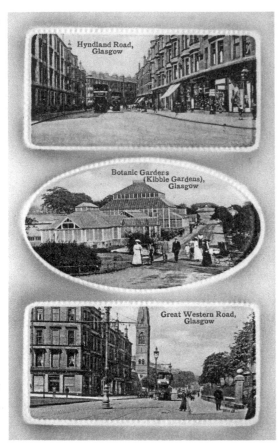

Hyndland Road, Glasgow

Botanic Gardens (Kibble Gardens), Glasgow

Great Western Road, Glasgow

**Great Western Road and Bothwell Street**
The three distinct scenes in the above postcard image are all connected by Great Western Road, with Hyndland Road located a short distance from the Botanic Gardens and having a junction onto Great Western Road. Just half a mile from the western edge of Great Western Road is Bothwell Street. Running parallel to St Vincent Street and Waterloo Street, Bothwell Street lies east to west, from Pitt Street to Hope Street. The YMCA Bible Training Institute in Bothwell Street was constructed in 1879, extended in 1896, and demolished in 1980.

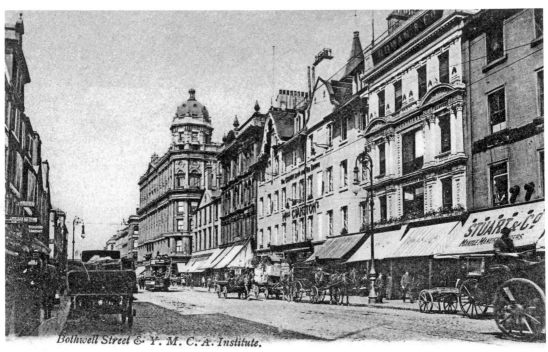

Bothwell Street & Y. M. C. A. Institute.

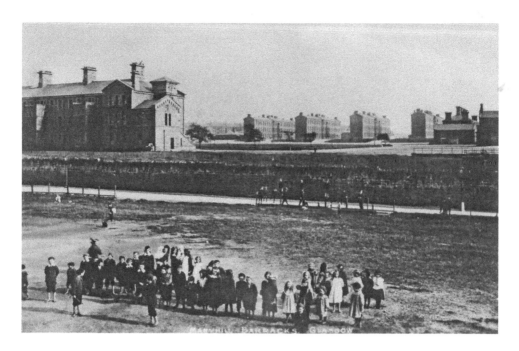

## Maryhill Barracks

In 1872 Maryhill Barracks, then Garrioch Barracks, opened to accommodate cavalry, infantry, and field artillery units, replacing the previous infantry barracks at Duke Street. The barracks were constructed following appeals from Glasgow Corporation for additional protection due to increasing concerns of public disorder and protest. In 1919 Maryhill Barracks was the marshalling location for the Argyll and Sutherland Highlanders and in 1921 became the base of the Highland Light Infantry in Glasgow. Maryhill Barracks became used as prisoner of war camp and Rudolf Hess, Deputy to Adolf Hitler, was held there in 1941. The barracks were decommissioned and demolished in the 1960s.

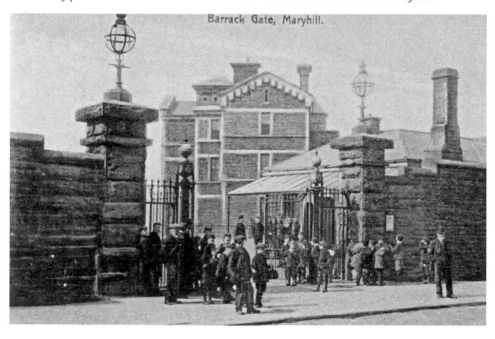

Barrack Gate, Maryhill.

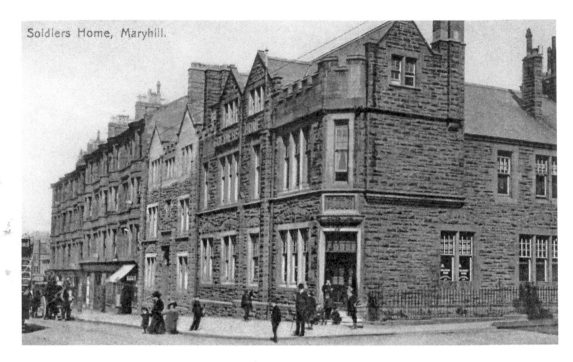

Soldiers Home, Maryhill.

## Glasgow Soldiers' Home and Stobhill Hospital

Located on the corner of Maryhill Road and Ruchill Street, close to Maryhill Barracks, Glasgow Soldiers' Home opened in 1899 to provide respite for soldiers and their families. The home closed in 1959 and the listed building has more recently been used as a nightclub. At the other side of north Glasgow, in the Springburn area, Stobhill Hospital was opened in 1904 as a Poor Law hospital, providing free healthcare to those who were destitute. During the Second World War, Stobhill was prepared to receive air-raid casualties; however, it was too far away to accommodate the injured from the Clydbank Blitz.

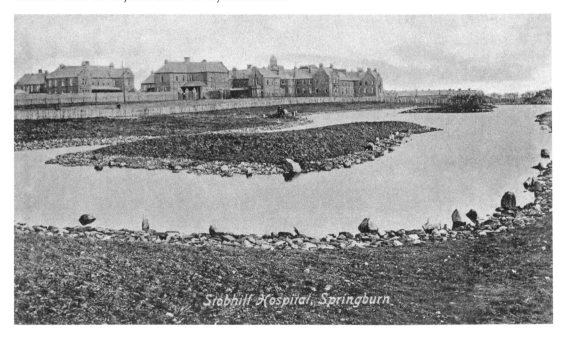

Stobhill Hospital, Springburn

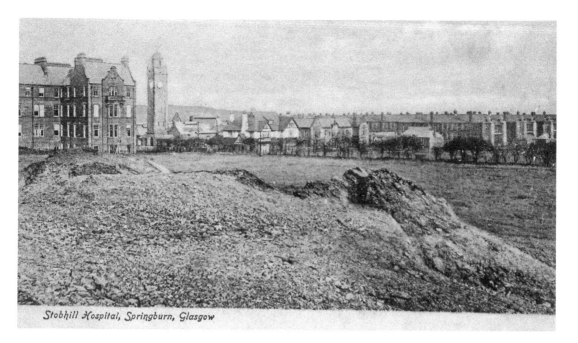

*Stobhill Hospital, Springburn, Glasgow*

## Stobhill Hospital

In 1899 the local council paid £6,000 for 47 acres of land in the Springburn area of Glasgow, with the foundation stone of Stobhill Hospital laid in 1901. The marsh nature of the site created significant problems during building works and many horses died during construction. The hospital was significantly extended and modernised, with a maternity unit added in 1931, a geriatric unit in 1953, a new pharmacy in 1961, and a day surgery unit in 1993. An entirely new Stobhill Hospital building opened in 2009, with the landmark clock tower protected as a listed building.

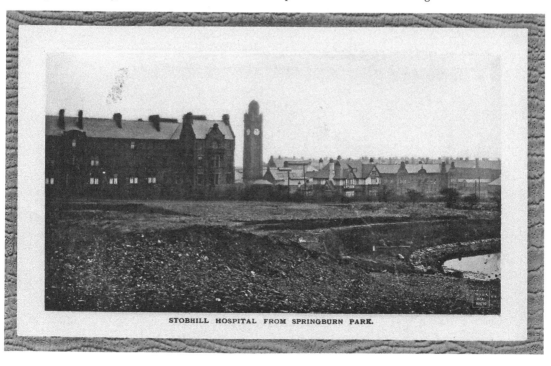

STOBHILL HOSPITAL FROM SPRINGBURN PARK.

87

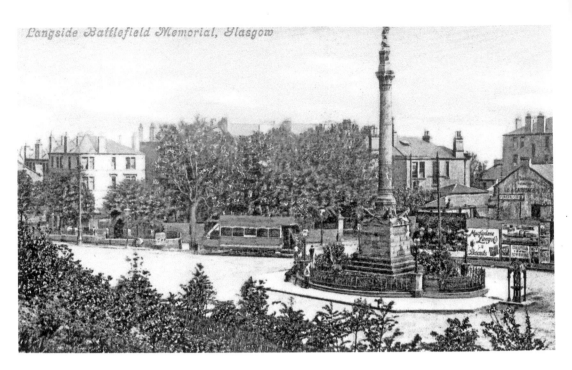

## Battlefield Memorial and Cathcart Road

Located next to Queen's Park, the Langside Battlefield Memorial was constructed in 1887 to commemorate the Battle of Langside in 1568. At the Battle of Langside, Mary Queen of Scots' army was defeated by the forces of James Stewart, Regent of Scotland, acting in the interests of the infant James VI. The Battle of Langside resulted in this area of Glasgow being known as Battlefield. Just east is Cathcart Road, named for the White Cart Water that flows through this area of Glasgow from Linn Park. In 2014 the Cathcart area was named one of the most attractive areas to live in Scotland following a study by Royal Mail.

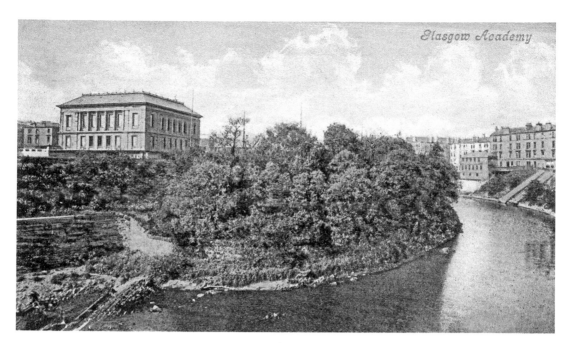

*Glasgow Academy*

## Glasgow Academy and Kelvin Bridge

Founded in 1845, the Glasgow Academy is the oldest continuously independent school in Glasgow. Located on the banks of the River Kelvin, in the Kelvinbridge area of Glasgow, the academy accommodates approximately 1,350 pupils each year and notable alumni include *Peter Pan* author J. M. Barrie, and former First Minister of Scotland Donald Dewar. Kelvin Bridge is located nearby, carrying the A82 Great Western Road over the River Kelvin, and was originally constructed in 1838.

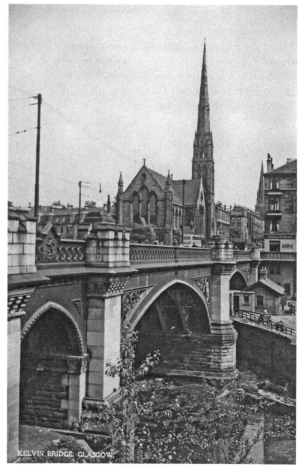

KELVIN BRIDGE, GLASGOW.

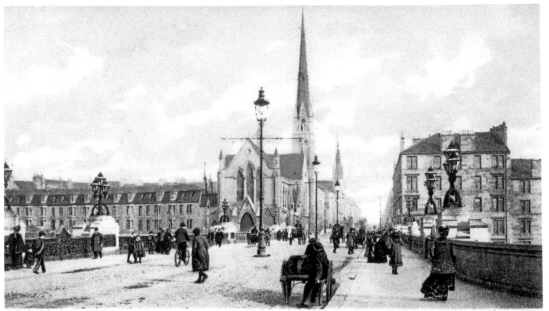

*Kelvin Bridge & Great Western Road.*  Glasgow.

## Kelvin Bridge

Looking east along Great Western Road, these postcard images show the current Kelvin Bridge, constructed in 1891 to replace the previous stone bridge with this cast-iron structure. The two church spires seen in both postcard images are from the Landsdowne Church, seen closest to the River Kelvin and constructed in 1862, and those of St Mary's Episcopal Cathedral, located further east on Great Western Road and opened in 1884. The former Landsdowne Church has more recently been used as a community space and a theatre.

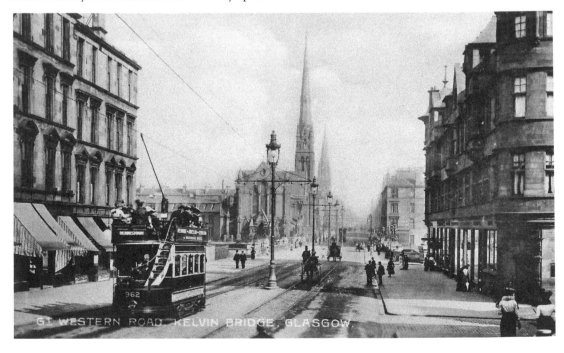

GT WESTERN ROAD, KELVIN BRIDGE, GLASGOW.

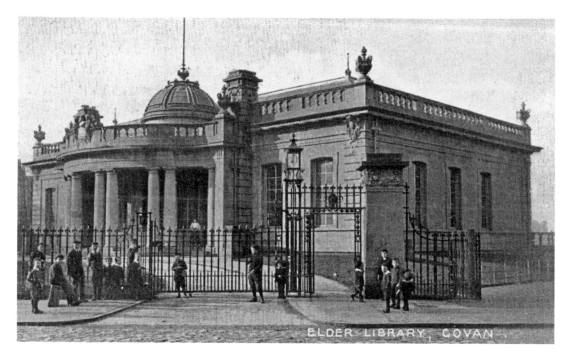

Elder Library and Queen Margaret Bridge

Located in the Govan area of Glasgow, Elder Library was opened in 1903 by Andrew Carnegie, following funding granted by Isabella Elder, widow of the shipbuilding magnate John Elder. The building cost £10,000 to construct, with a further £17,000 donated for future maintenance. Isabella Elder also supported the new Queen Margaret College – the first in Scotland to offer higher education to women – by purchasing North Park House and allowing the college to use it rent free. The below postcard image looks south on Queen Margaret Drive and over the River Kelvin towards Great Western Road and Byres Road.

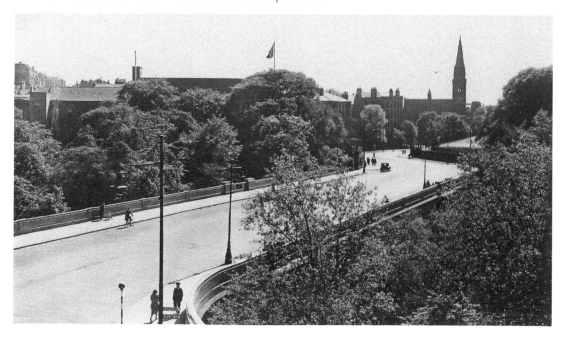

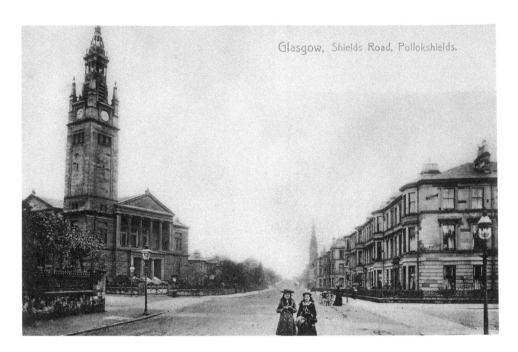

## Shields Road and Eglinton Toll

The Pollokshields area of Glasgow was established in 1849 by the wealthy Stirling-Maxwell family and features notable contributions from renowned Glasgow architects including Alexander 'Greek' Thomson and Charles Rennie Mackintosh. The above postcard image shows the junction of Shields Road and Nithsdale Road, and the former Pollokshields West Free Church, constructed in 1878 and most recently operating as a nursery and nursing home. St Andrew's Cross, better known as Eglinton Toll, is where Eglinton Street meets Pollokshaws Road and Victoria Road. Named after St Andrew due to the road layout forming a saltire, a dividing fence was constructed in 1946.

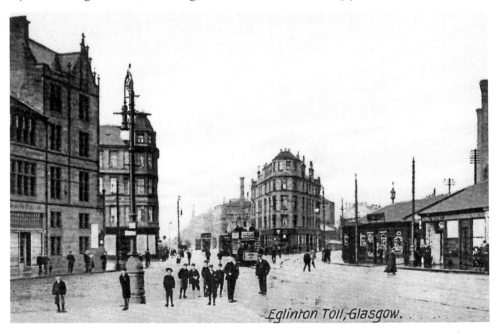

Eglinton Toll, Glasgow.

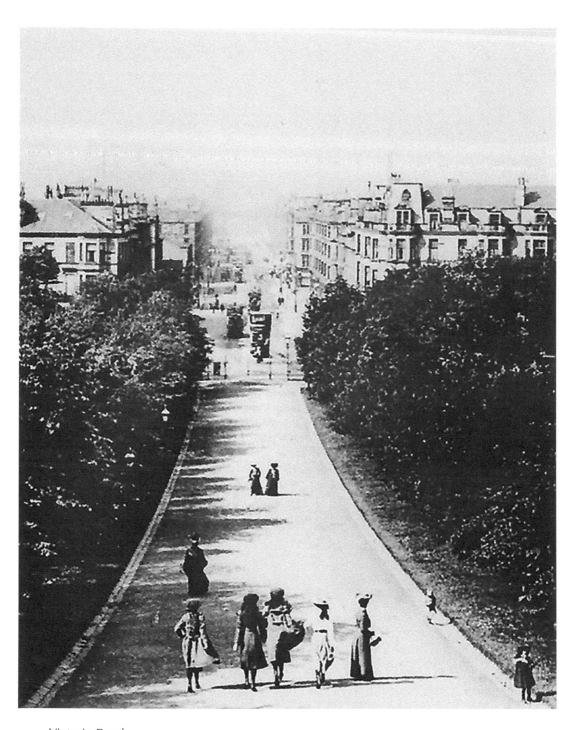

Victoria Road

Looking north onto Victoria Road from the tree-lined avenue of Queen's Park, this postcard image looks onto the junction of Victoria Road and Queen's Drive. Victoria Road is the main road in the Govanhill area and is almost 1 mile long from Queen's Drive to Pollokshaws Road. Govanhill was formed in 1877 by William Dixon, who opened iron furnaces in the area that became known as Dixons Blaxes; it officially became part of the city of Glasgow in 1891.

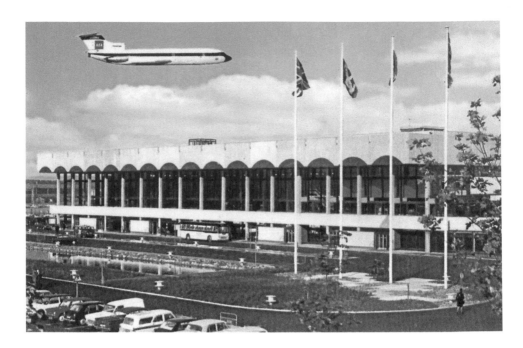

Glasgow International Airport
Originally opened in 1932 as Abbotsinch Airport, a Royal Air Force base, the previous Glasgow Airport was located 2 miles away in Renfrew. The passenger airport opened at Abbotsinch in 1966, with the terminal building designed by renowned architect Sir Basil Spence and constructed at a cost of £4.2 million. The terminal building has subsequently been expanded and refurbished on a number of occasions, with significant alterations to the road access arrangements following the attempted terror attack on the airport in 2007. In 2016 Glasgow International Airport was the second-busiest airport in Scotland and the eighth-busiest airport in the United Kingdom.

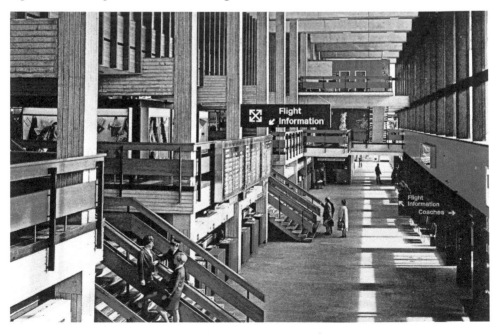

# Also available from Amberley Publishing

ADAM SMITH

## CUMBERNAULD

### THROUGH TIME

*The No. 1 Best Selling Colour Local History Series*

OVER
**500,000**
COPIES
SOLD

This fascinating selection of photographs traces some of the many ways in which Cumbernauld has changed and developed over the last century.

978 1 4456 4522 3
Available to order direct 01453 847 800
www.amberley-books.com